Images of Modern America

THE LAND OF OZ

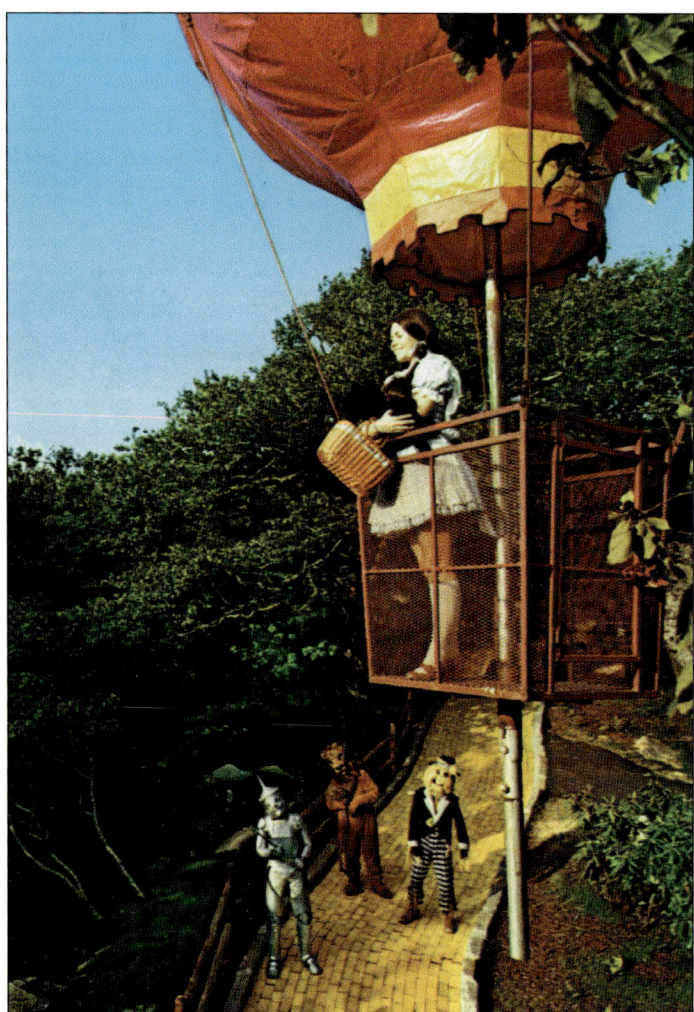

The simulated hot air balloon ride was perhaps the most identifiable attraction in the Land of Oz park—possibly because it was the theme park's only ride. The point at which it passed over the Yellow Brick Road made for some terrific photographic opportunities. (Author's collection.)

ON THE FRONT COVER: No one should need an introduction to this famous quartet. Dorothy, the Scarecrow, the Cowardly Lion, and the Tin Woodman (and Toto, too) stand ready to welcome readers to this history of their home atop Beech Mountain in western North Carolina. (Author's collection.)

UPPER BACK COVER: See page 74 (Chris Robbins collection)

LOWER BACK COVER (from left to right): See page 77 (Chris Robbins collection), see page 39 (author's collection), see page 31 (Emerald Mountain Realty collection)

Images of Modern America

THE LAND OF OZ

Tim Hollis

Copyright © 2016 by Tim Hollis
ISBN 978-1-4671-2452-2

Published by Arcadia Publishing
Charleston, South Carolina

Printed in the United States of America

Library of Congress Control Number: 2016943298

For all general information, please contact Arcadia Publishing:
Telephone 843-853-2070
Fax 843-853-0044
E-mail sales@arcadiapublishing.com
For customer service and orders:
Toll-Free 1-888-313-2665

Visit us on the Internet at www.arcadiapublishing.com

Dedicated to the memory of Jack Pentes (1931–2015), who took the magical Land of Oz out of the pages of a book and images on movie film and turned it into a "real truly live place"

Contents

Acknowledgments		6
Introduction		7
1.	No Place Like Home	9
2.	Follow the Yellow Brick Road	23
3.	The Emerald City	37
4.	How About a Little Fire, Scarecrow?	47
5.	The Merry Old Land of Oz	59
6.	Beyond the Rainbow	81
7.	Return to Oz	87

Acknowledgments

Compiling a pictorial history of the Land of Oz presents its own set of challenges, not the least because the park has had two distinct lives. There was its original period of operation that lasted from 1970 to 1980 and then its current incarnation as a sort of private garden that began in 1990. In between the two was even a third life, when it was an overgrown, abandoned remnant of a theme park. Getting all three to fit together required the help of historians, former tourists, current caretakers, and others who have had a part in its past, present, and future. For the book existing in its present form, we would like to thank Sean Barrett; Angie Andrew Blackmon; Tommy Brigham; Greta Browning, Appalachian State University; Billy Ferguson; Jana Greer; Ann Iles, Beech Mountain Historical Society; Billy Ingram; J.J. Jeffers; Marilou Johnson; Cindy Keller, Emerald Mountain Realty; Jeremy and Michele Kennedy; Alice Leggett LaMar; Keith Longiotti, University of North Carolina; Allen Lyndrup; French Moore; Rodger Motiska; Dorne Pentes; Chris Robbins; Harry Robbins; Spencer Robbins; John Rose; and Stewart Sonderman.

Unless otherwise credited, all images come from the author's personal collection.

Introduction

The story of how a park based on L. Frank Baum's *The Wonderful Wizard of Oz* came to exist on a mountaintop in northwestern North Carolina actually begins with another innovative aspect of tourism for that region of the country. In 1966, the three Robbins brothers (Grover, Harry, and Spencer), who were already well known in North Carolina's tourist industry, announced plans to build an entertainment complex on top of Beech Mountain, a 5,506-foot summit near Banner Elk. The main feature of their new project would be a ski resort; the idea was a novel one for the southeastern part of the United States, where obviously the ski season was much shorter than in Colorado or New England. For that reason, the Robbins family also wanted to do something that would make use of the ski facilities during the long off-season.

The Robbinses turned to their valued associate, Charlotte designer Jack Pentes, to come up with an idea for their summer attraction on Beech Mountain's summit. In recounting the story, Pentes often related how he was first shown the property for the proposed development, and it was the indigenous trees, twisted and gnarled by centuries of exposure to the harsh mountain climate, that reminded him of the crabby apple trees in MGM's 1939 movie version of *The Wizard of Oz*. As it turns out, though, Pentes had long wanted to create a theme park based on the movie (and Baum's book). In the early 1960s, he had been responsible for a walk-through Oz display that served as a Christmas feature for the Charlottetown Mall, and ever since, he had dreamed of doing basically the same thing on a full-scale basis. When he suggested to the Robbinses that they build the Land of Oz atop Beech Mountain, the brothers heartily agreed.

Considering that Baum's book had been published in 1900, it is somewhat surprising that it took nearly 70 years for it to become the basis for a theme park. Way back in 1906, Baum himself had announced plans to build an Oz park on a small island off the coast of California; had he done so, it might have qualified as the first "theme park" in American history, beating an entrepreneur named Walt by a half-century. From approximately the same period, fading newspaper clippings mention some Oz attractions in a Chicago amusement park without being specific enough to identify just what they were. The 1933 Chicago World's Fair incorporated Oz characters into its children's area known as the Enchanted Island, and Cincinnati's Coney Island park also had a Land of Oz section at one time. Nothing on the scale of what Pentes and the Robbins brothers had in mind had ever been attempted, however.

Their timing was nothing if not fortuitous. In the 1960s, most people's familiarity with the Oz tale was probably about equally divided between Baum's book and the 1939 movie, which was shown on network television once each year. In those days before home video, that single annual exposure was the extent of its reputation. Baum's story and characters had gone into public domain in 1956, so after that point, anyone could do whatever they wanted with the underlying property as long as it did not resemble the appearance of the movie. Using elements created by MGM, including the music, required a separate licensing agreement. (It should be noted that Baum went on to pen 13 more Oz novels before his death in 1919. His publisher subsequently assigned other authors to continue the series, which officially ended at 40 books in 1963.)

The MGM film was thrust to the forefront of the public's Oz consciousness at precisely the same time the North Carolina park was being built. In June 1969, Judy Garland died, inspiring an outpouring of emotion from her fans that has not ended to this day. In May 1970, MGM announced an enormous auction of its warehouses of props and costumes, which seemed to many to signal the end of "old Hollywood," if such a thing had ever really existed. Both of these events would have a great influence on what people would see at Oz, Beech Mountain–style.

Spencer Robbins was sent to the MGM auction with a $25,000 budget to purchase as many costumes and props from *The Wizard of Oz* as possible. Such an amount seems pitifully small today, but he managed to pick up some real bargains. The main competition was former MGM star Debbie Reynolds, who was a passionate collector of movie memorabilia and intended to start a museum to display her accumulated relics. Spencer Robbins made an agreement with Reynolds that if she would refrain from bidding on any Oz artifacts, they would be loaned to her during the fall and winter months when the park would be closed. She agreed, and even signed on to be the guest at the grand opening of Oz. As it turned out, the expense and trouble of shipping such unique items from North Carolina to California and back proved impractical, so once they were installed on Beech Mountain, they never left.

North Carolina's Land of Oz opened on schedule in June 1970 and soon became one of the state's top attractions. Unfortunately, just a few years later, the entire tourism industry began suffering a series of setbacks, beginning with the 1973 oil embargo in the Middle East that set off a stateside panic that the United States was running out of energy. Gas prices soared, speed limits were lowered, and attractions such as Oz that sat somewhat off the beaten path—i.e., not alongside an interstate highway—felt the pinch the most. Still, Oz merrily skipped down its own Yellow Brick Road for 10 years, and we are about to revisit those sights and also find out what has been happening in the old neighborhood since then. Beware of wicked witches and flying monkeys; we're off to see the Wizard!

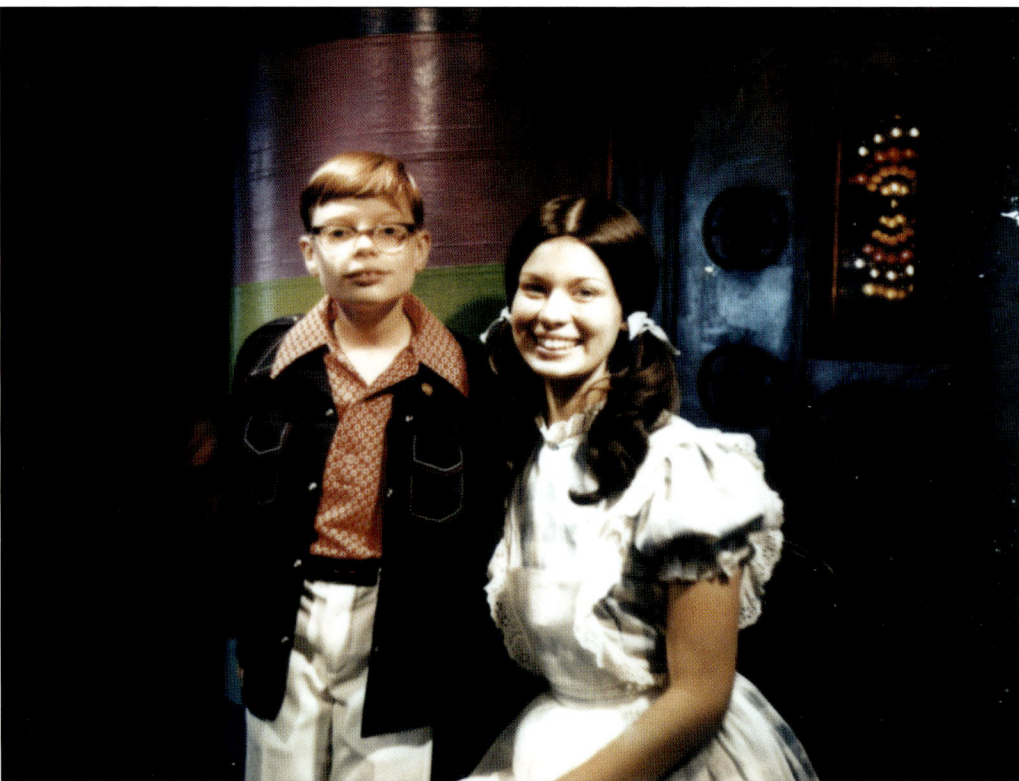

Tim Hollis made only one visit to the Land of Oz during the 10 years the park was open. That was in July 1975, and here, he is hanging out with a mighty cute Dorothy in an area designated as the Wizard's Chamber. This was a sort of holding area to delay groups that were approaching the end of the Yellow Brick Road too quickly, thus chancing seeing the surprise ending of the Magic Moment stage show.

One
No Place Like Home

Grover, Harry, and Spencer Robbins had a twofold purpose for wanting to build some sort of attraction at the summit of Beech Mountain. One was so the chairlift and other ski facilities could be used during the summer months, and the other was to attract potential residents to the largely undeveloped neighborhood.

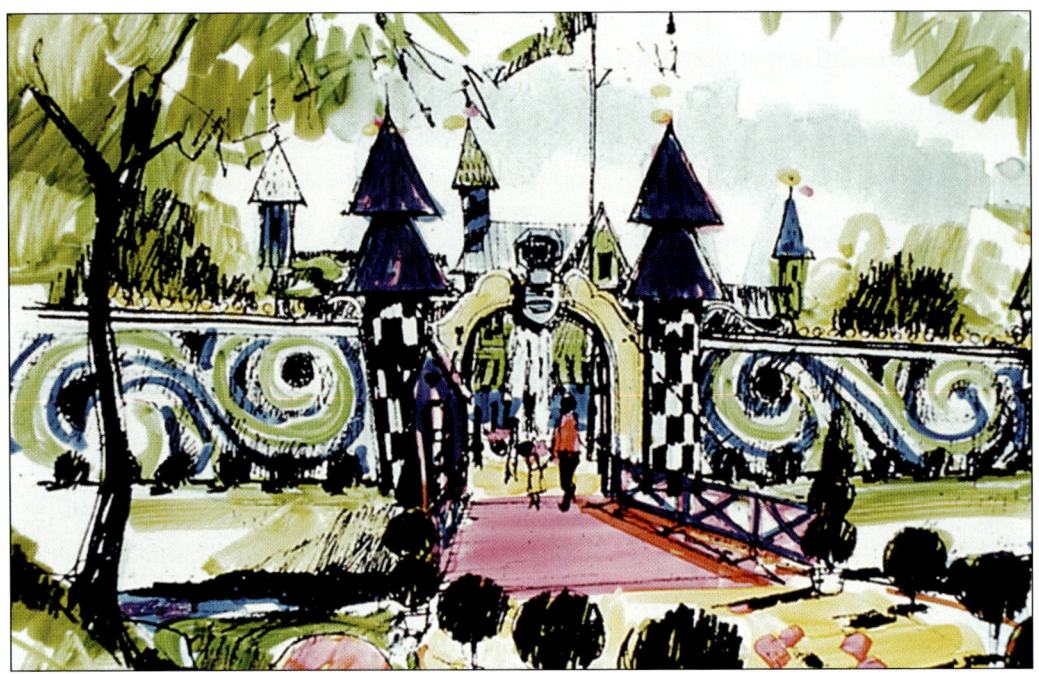

Artist Joe Sonderman was an important member of the team at Pentes Design in Charlotte. He was tasked with making the preliminary sketches that would serve as the basis for the look of the new Land of Oz park. These are just two of the surviving examples of his preparatory work. (Both, Rodger Motiska Design, LLC, collection.)

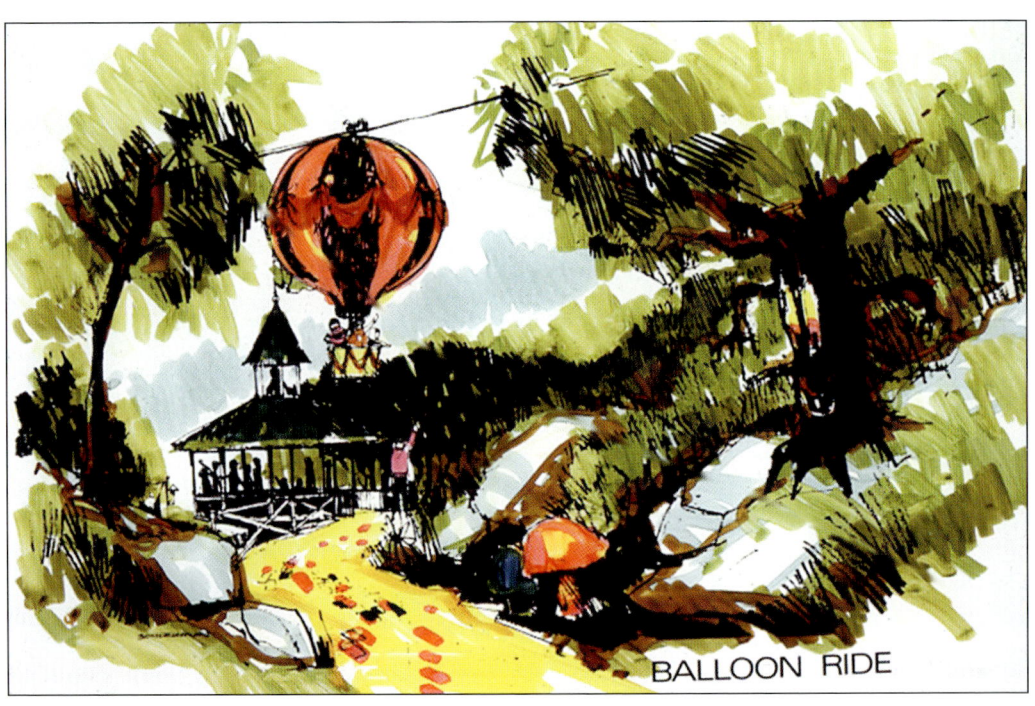

Jack Pentes said that it was these beech trees, gnarled and twisted by centuries of exposure to the harsh mountain climate, that first gave him the idea that the Robbins family's property could be turned into the Land of Oz. As a longtime fan of the story, it proved to be a dream project for him.

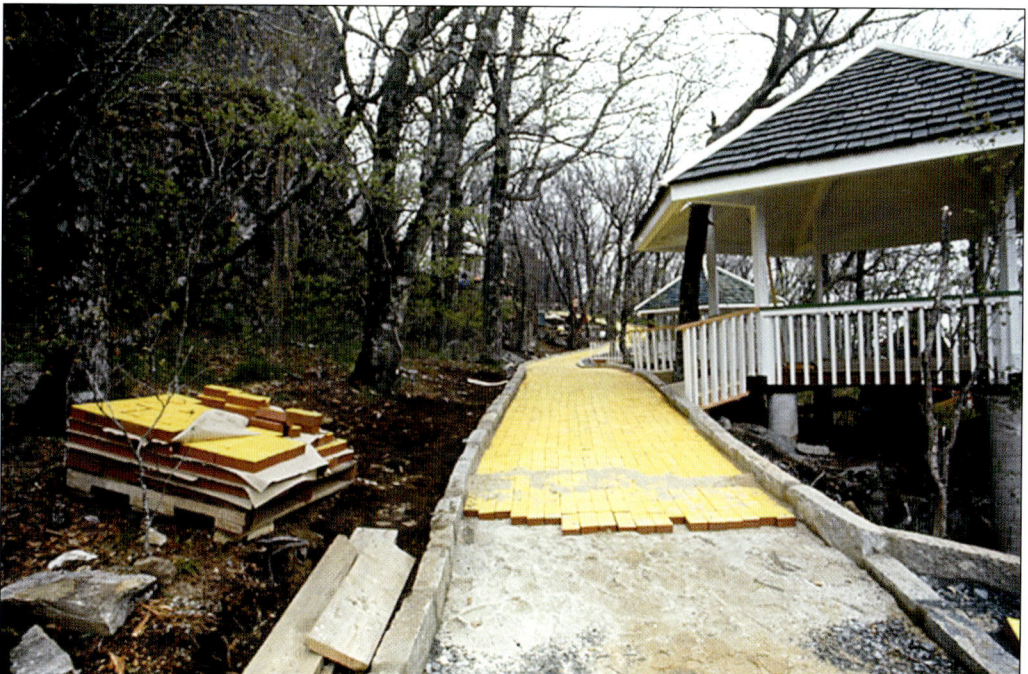

Probably the most important landmark in the new Oz park was the Yellow Brick Road, which was laid out in a winding uphill-and-downhill path. Here, during the winter of 1969–1970, the famed highway looks like it still has some way to go before completion. (Rodger Motiska Design, LLC, collection.)

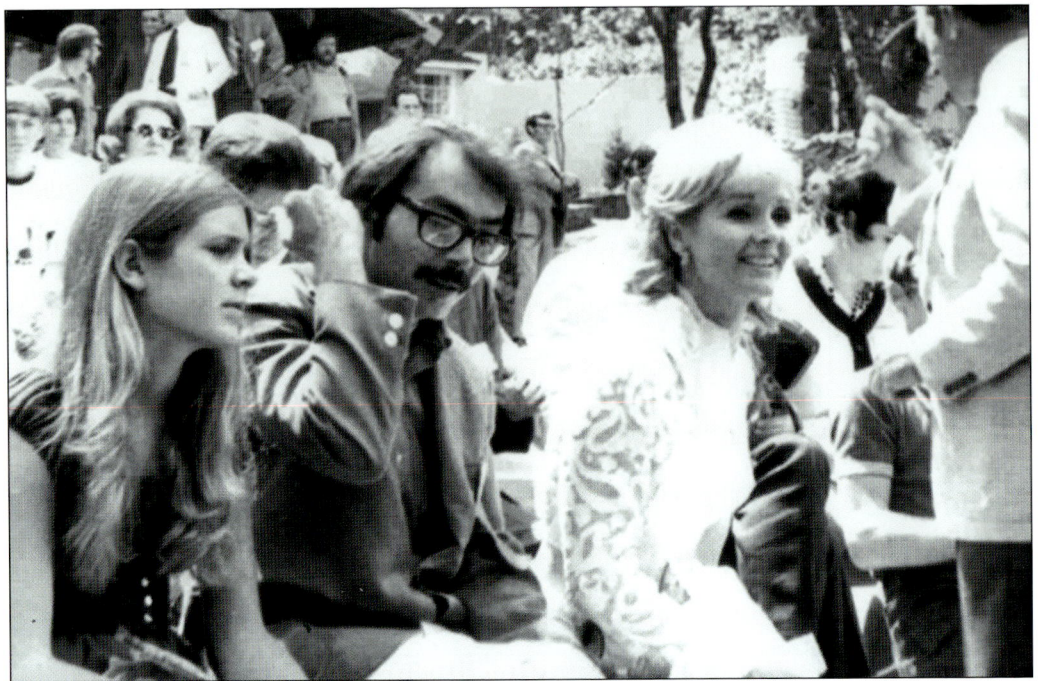

At the grand opening of Oz on June 15, 1970, Jack Pentes is seated between special guest star Debbie Reynolds (right) and Reynolds's 13-year-old daughter Carrie Fisher (left), seven years before she won fame as *Star Wars*' Princess Leia. (Emerald Mountain Realty collection.)

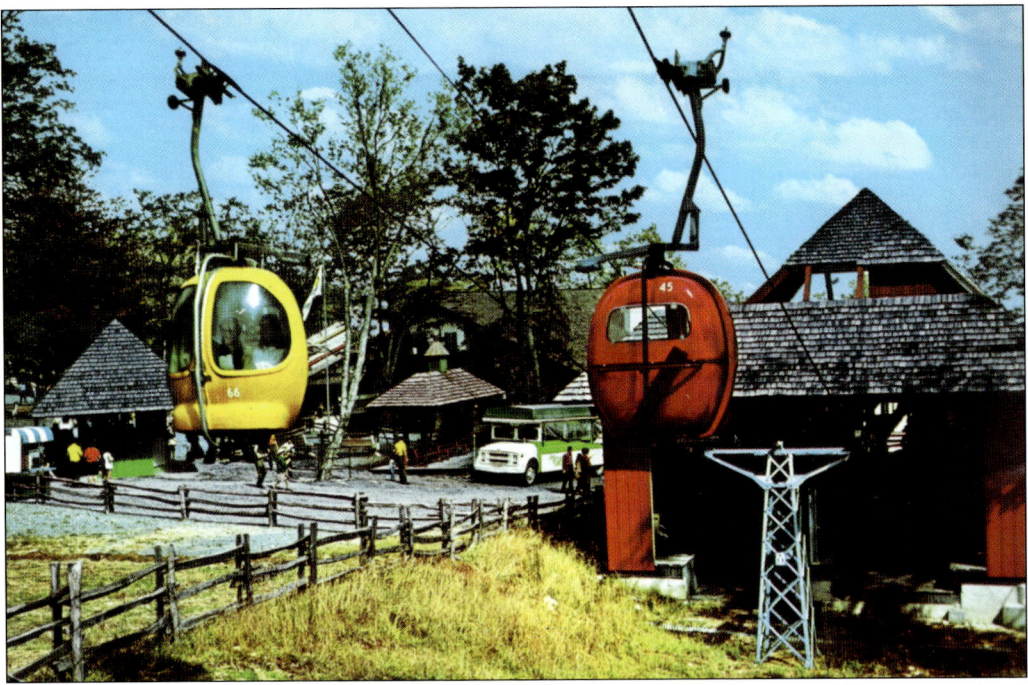

Tourists had several choices of transportation to get from Beech Mountain's ski resort to Oz at the summit. Two of those can be seen here: the enclosed gondolas, which left riders' feet and legs exposed, and a surrey bus that made the drive up a winding mountain road.

The third mode of access to the mountaintop was the traditional, but less glamorous, chairlift that, of course, also served to transport skiers during the winter months. (Angie Andrew Blackmon collection.)

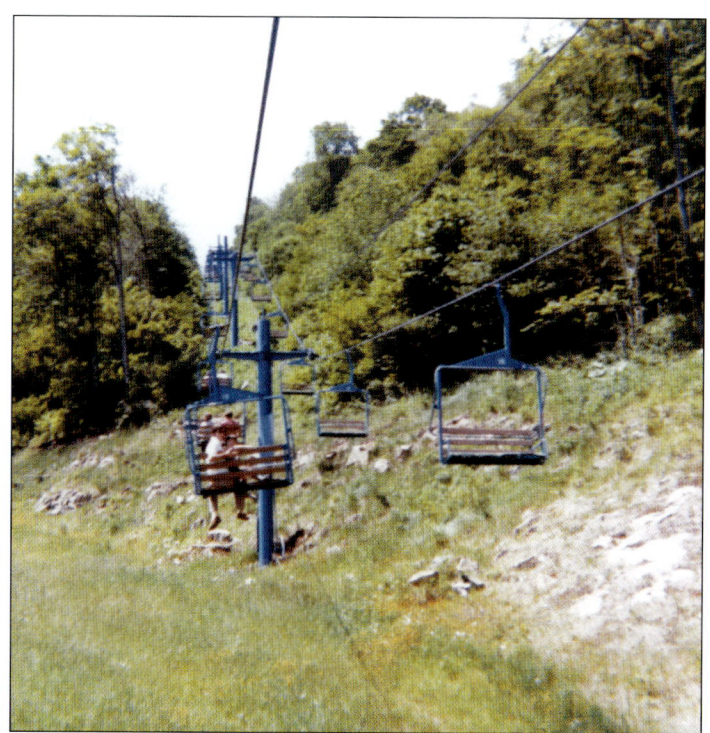

Arriving at the entrance to Oz, visitors first encountered the Oz Museum. As with the chairlift, the building served another purpose—headquarters for the ski patrol—during the off-season, while the contents were warehoused elsewhere. (Emerald Mountain Realty collection.)

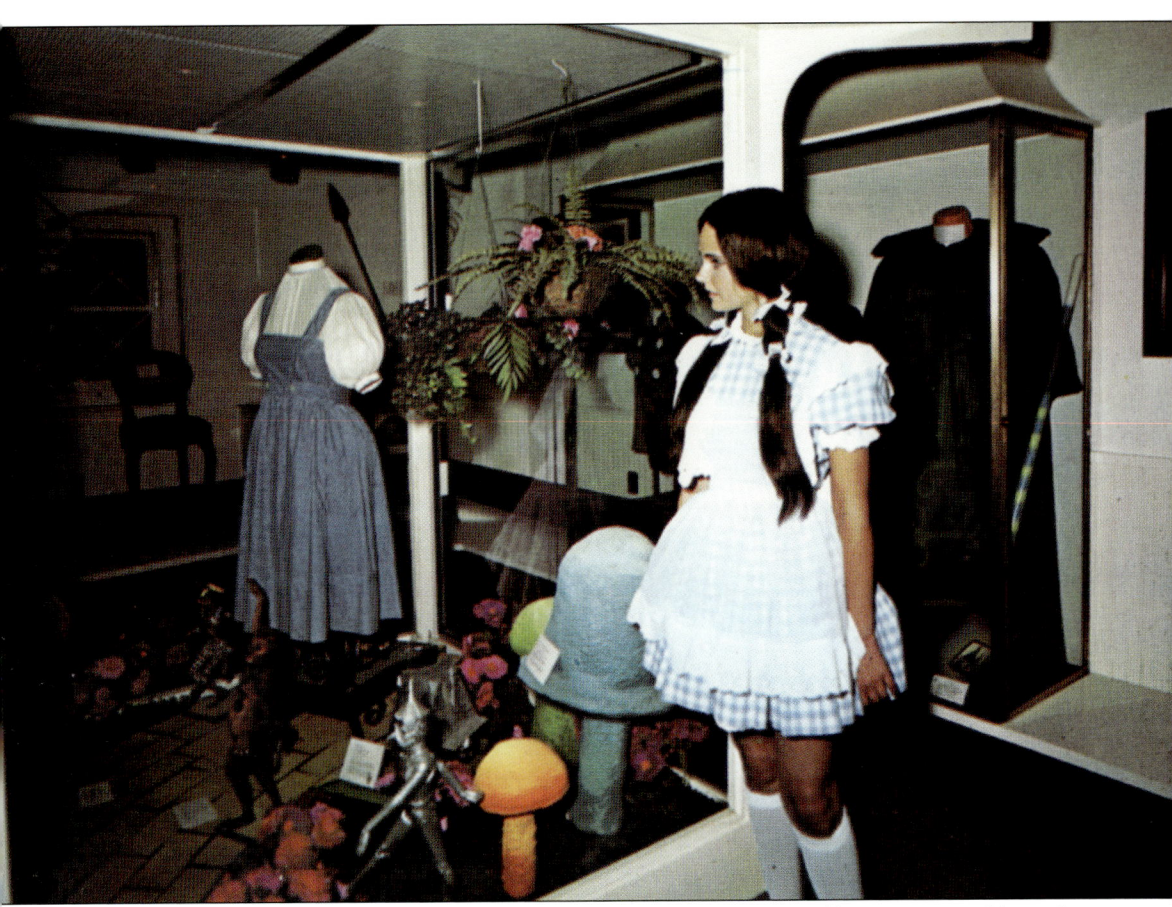

The Oz Museum contained the movie props that had been purchased by Spencer Robbins during MGM's enormous auction of its archives in May 1970. Clearly seen in this angle are one of Dorothy's gingham dresses and the cape worn by Frank Morgan as the guard outside the Wizard's throne room. Next to the cape is the decorated shovel with which the Scarecrow of Oz, Ray Bolger, presided during ground-breaking ceremonies for the park.

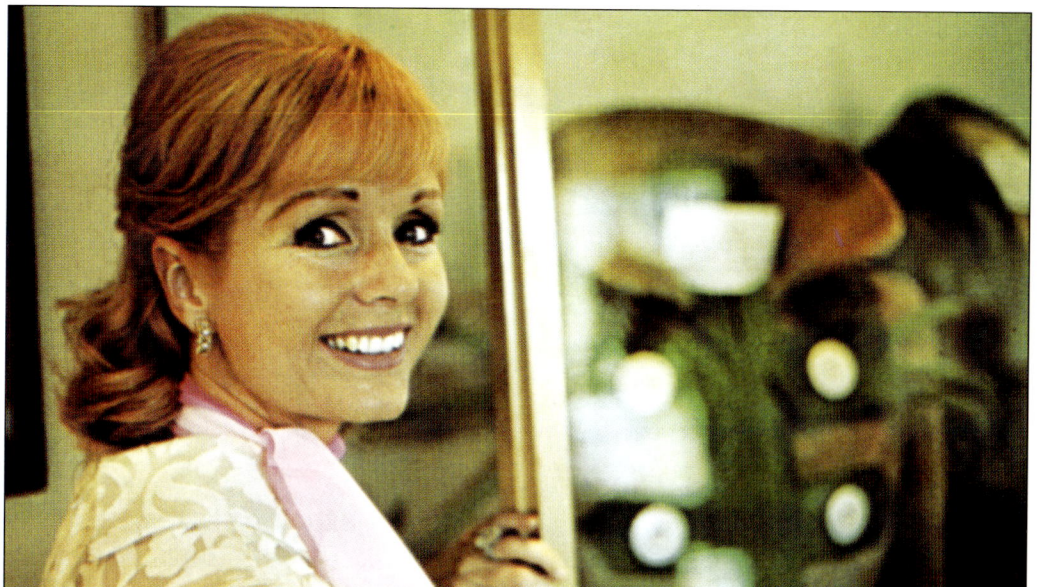

Debbie Reynolds was photographed in the Oz Museum during the grand opening festivities. Although she was originally to have joint custody of the contents for her own Hollywood museum, she never got around to borrowing them after the park opened.

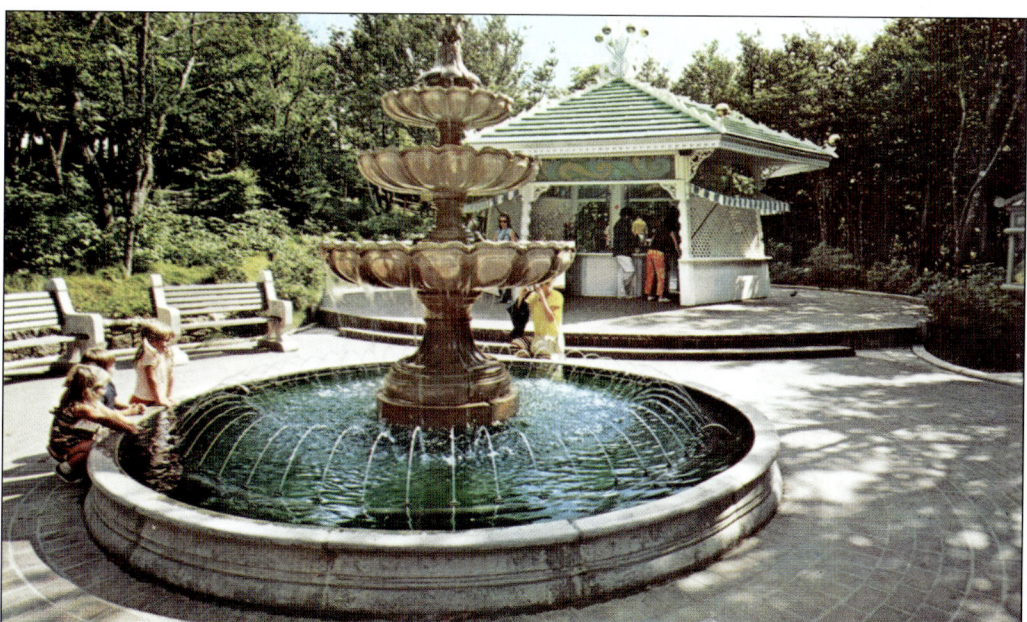

The Fountain of Youth was on hand to put everyone in the proper mood for the adventure that was to come. But not to ignore the practical side of the tourism business, the gazebo in the background was there to sell film and other such possibly forgotten necessities.

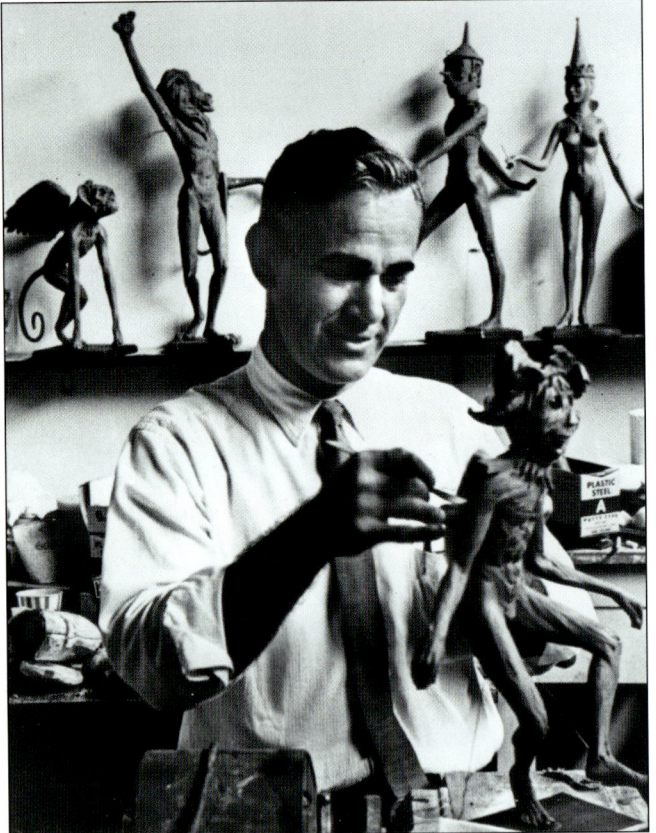

The next stop was the Judy Garland Memorial Overlook, a tribute to the famed performer who had died exactly one year before the Oz park opened. On the plaque was a quote from the movie: "If I ever go looking for my heart's desire again, I won't look any further than my own back yard, because if it isn't there, I never really lost it to begin with."

The Judy Garland bust was the work of another Pentes Design veteran, sculptor Austin Fox. He is seen here creating the look of some of the park's other characters; their finished versions can be glimpsed in the museum photograph back on page 14. (Emerald Mountain Realty collection.)

This breathtaking view of Elk Valley, as seen from the Memorial Overlook, was appropriately termed "Dorothy's back yard." The view is much the same today, with a few more houses and other buildings dotting the valley floor.

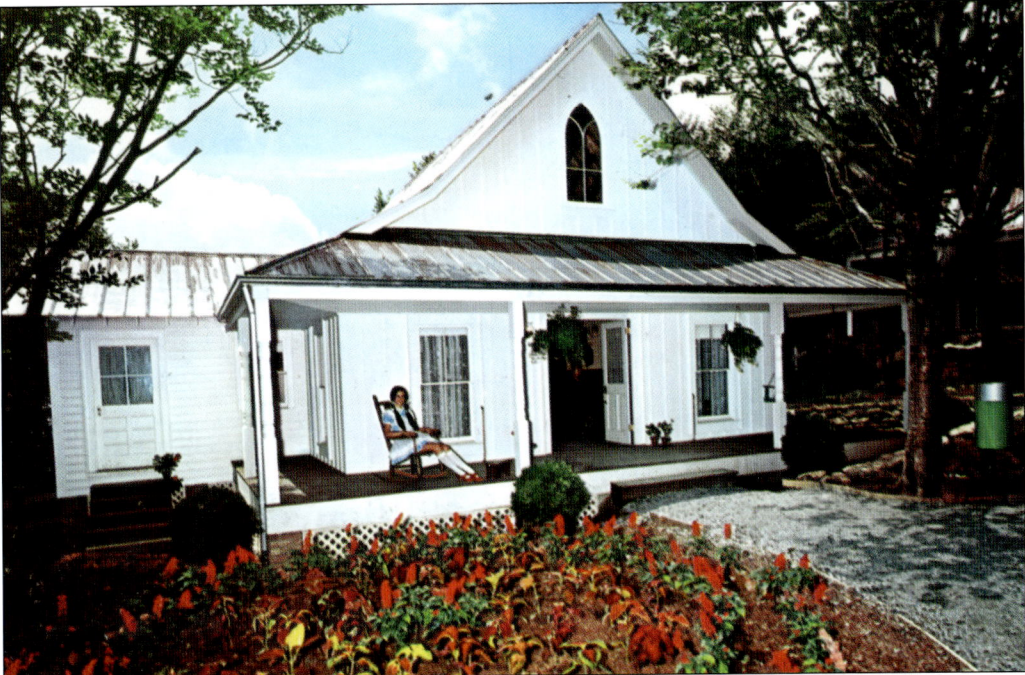

Here is the Gale farm. Instead of the one-room shack described in Baum's book, or the Depression-era house of the movie, Dorothy's farmhouse was patterned after the one in Grant Wood's famous *American Gothic* painting. One half expects to see Aunt Em and Uncle Henry posing solemnly with a pitchfork in front.

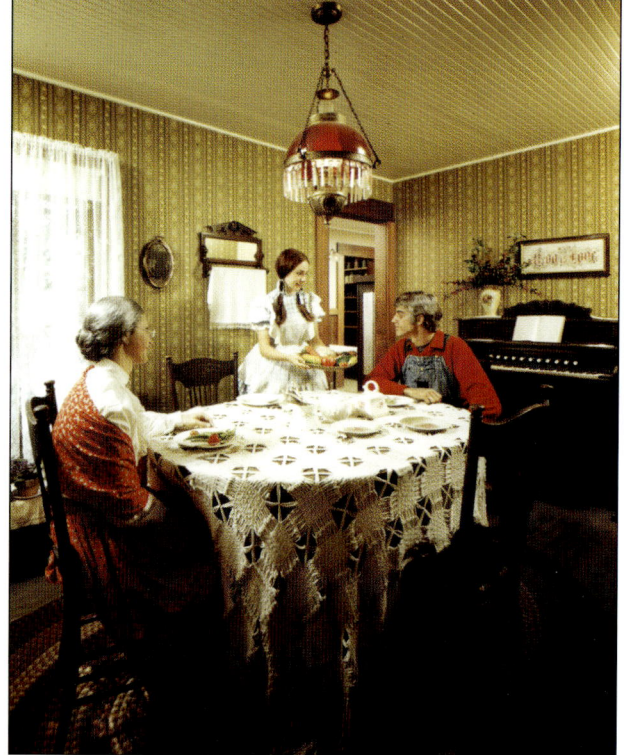

Say, just what sort of cloning experiments has Uncle Henry been fooling around with down on the farm, anyway? It took a fleet of Dorothys to work the various stations in the park that required their presence. (W.L. Eury Appalachian Collection, Appalachian State University.)

The Gale farmhouse was furnished with genuine period antiques, giving a most realistic atmosphere to set the mood for the fantasy that was to come. Actually, these publicity shots were practically the only time the elderly Gale couple could be seen; they were usually talked about without appearing in person. (Chris Robbins collection.)

Aha, so this is why Uncle Henry seemed so much more prosperous than folks remembered: in an early example of product placement, he sold advertising space on his silo to the Ralston-Purina Company of Checkerboard Square. All that was missing was a "SEE ROCK CITY" sign on the barn roof. (Chris Robbins collection.)

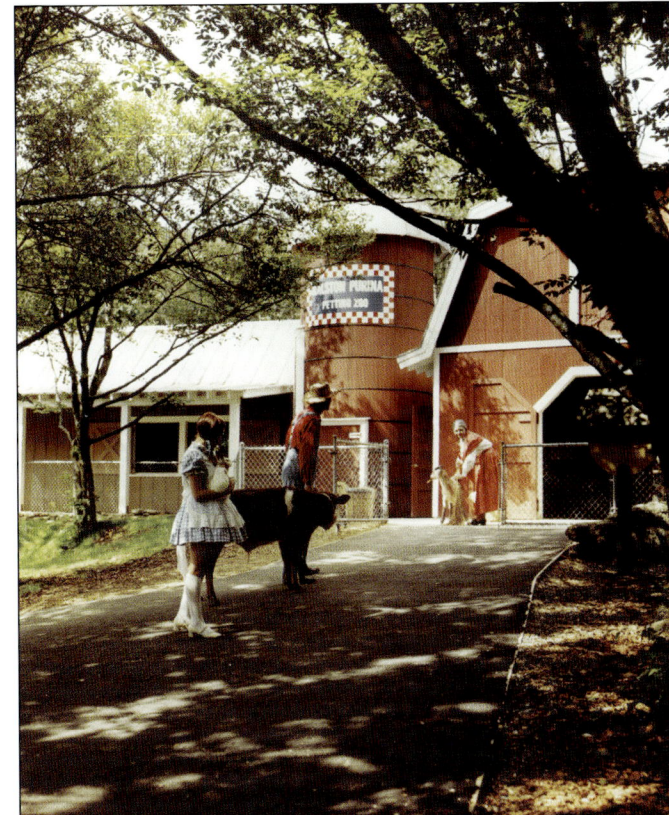

The interior of the barn served as a petting zoo where kids from both town and country could have a little fuzzy face time with live farm animals. (Emerald Mountain Realty collection.)

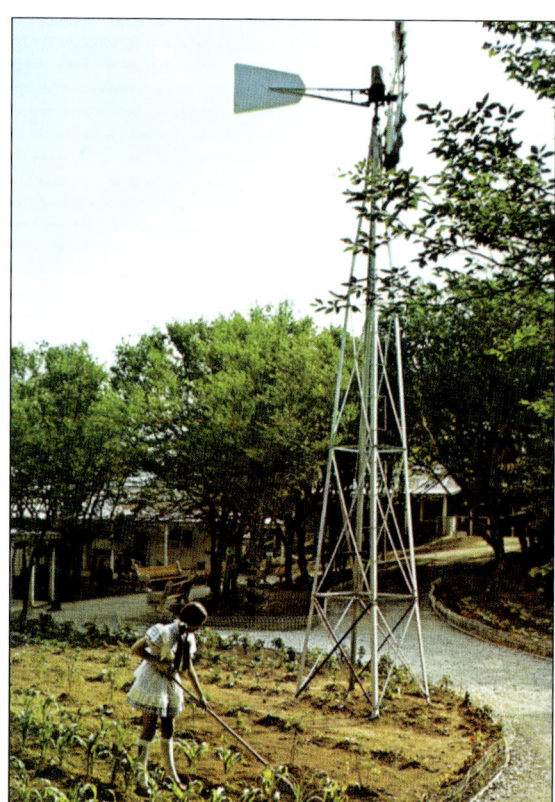

If this publicity shot is any indication, Dorothy did not have much of a chance to be lazy while living on the farm. With all that hard work to keep her healthy and strong, no wonder the Cowardly Lion cried when she slapped his face.

Like the petting zoo in the barn, the garden outside the Gale farmhouse was another living exhibit, with growing examples of flowers and vegetables in a natural setting. (Chris Robbins collection.)

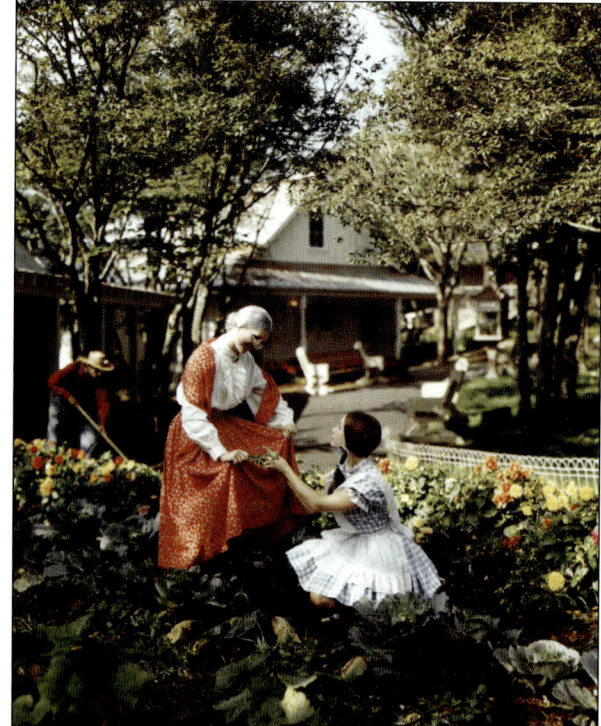

Stationed throughout the park were display cases such as this one to help visitors relate to what they were seeing. This was apparently a preliminary model of the full-scale farmhouse. (Rodger Motiska Design, LLC, collection.)

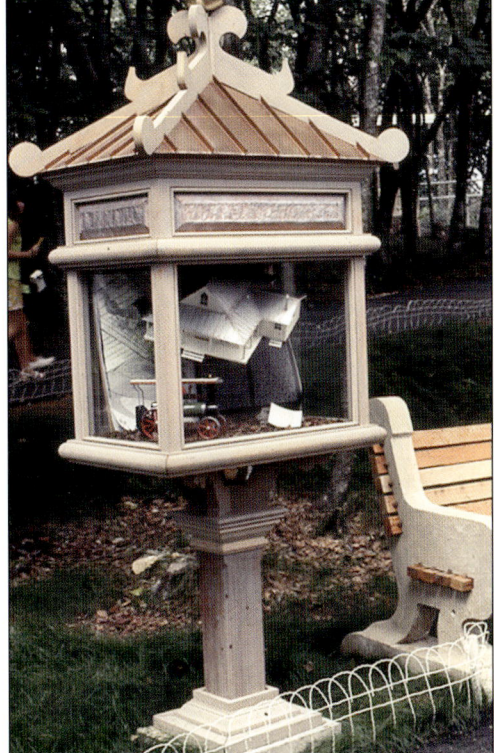

After touring the farmhouse, the sound of roaring wind prompted guests into the storm cellar, a dark maze of noise, ominous music, and film clips depicting people, animals, and scenery being propelled through the air. It was all designed to be as disconcerting as possible, leading back to what appeared to be the same upper level as before.

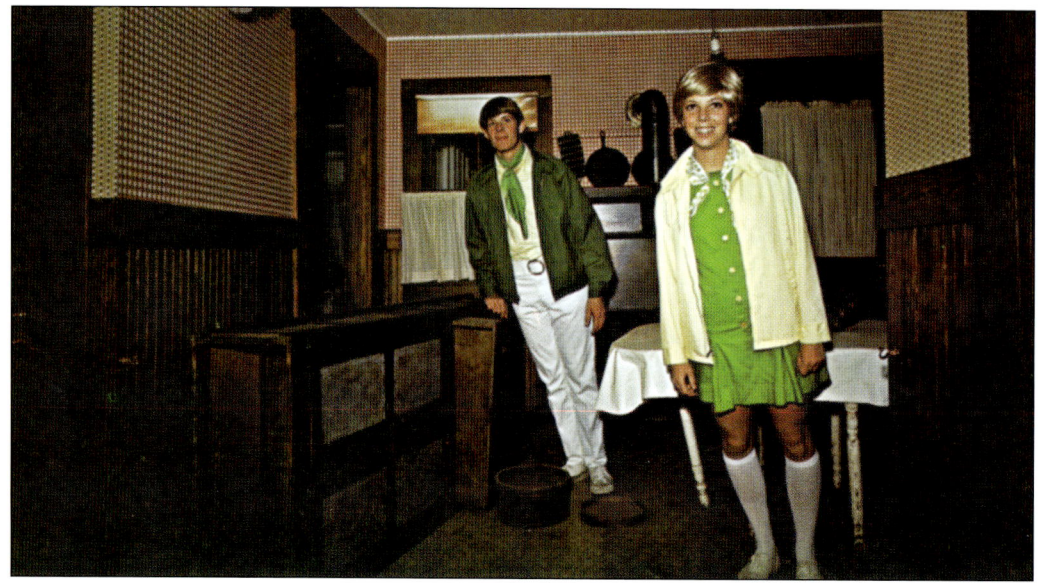

Amazingly, back at the top of the stairs, the farmhouse and its contents were the same, but the floor tilted several degrees, as if the house had been slammed into the ground. This made for some interesting angles as people made their way back to the front door. Obviously this was a second house that was connected to the first by the storm cellar maze.

Park employees had to be stationed at the top of the stairs to catch unwary visitors who nearly pitched headfirst when stepping onto the tilted floor. Even Dorothy looks a bit queasy here. (Photograph by Hugh Morton, North Carolina Collection, University of North Carolina at Chapel Hill, Wilson Library.)

Two

Follow the Yellow Brick Road

The storm having passed, Dorothy (and her Toto hand puppet) could finally begin their journey to see the wise and powerful Wizard of Oz. Notice her red shoes, which were not officially referred to as "ruby slippers." Those, being a creation of MGM's scriptwriters, would have violated copyright laws if used without permission. As most people know, Baum's magical shoes were silver, but the movie studio decided that red would be more eye-catching in Technicolor.

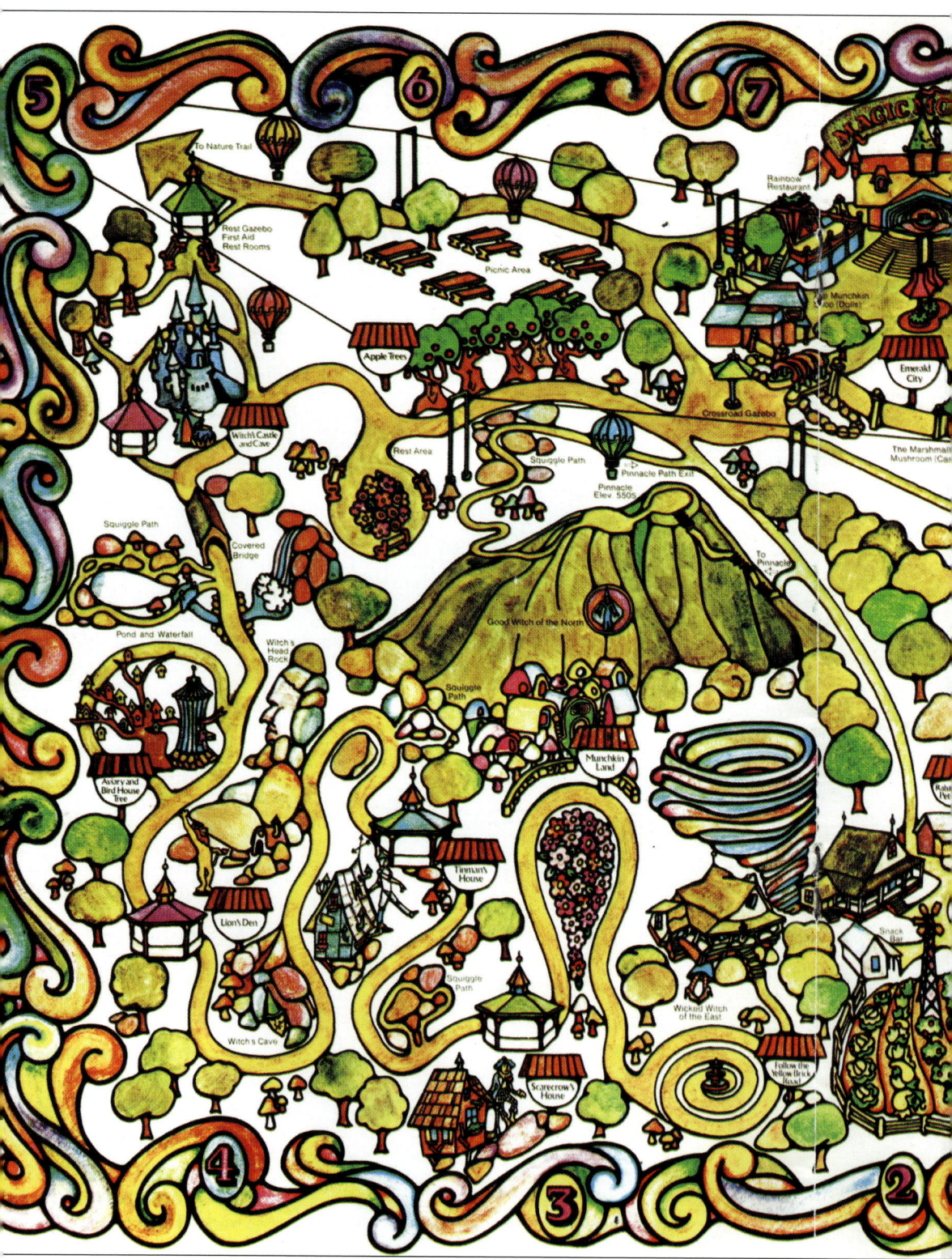

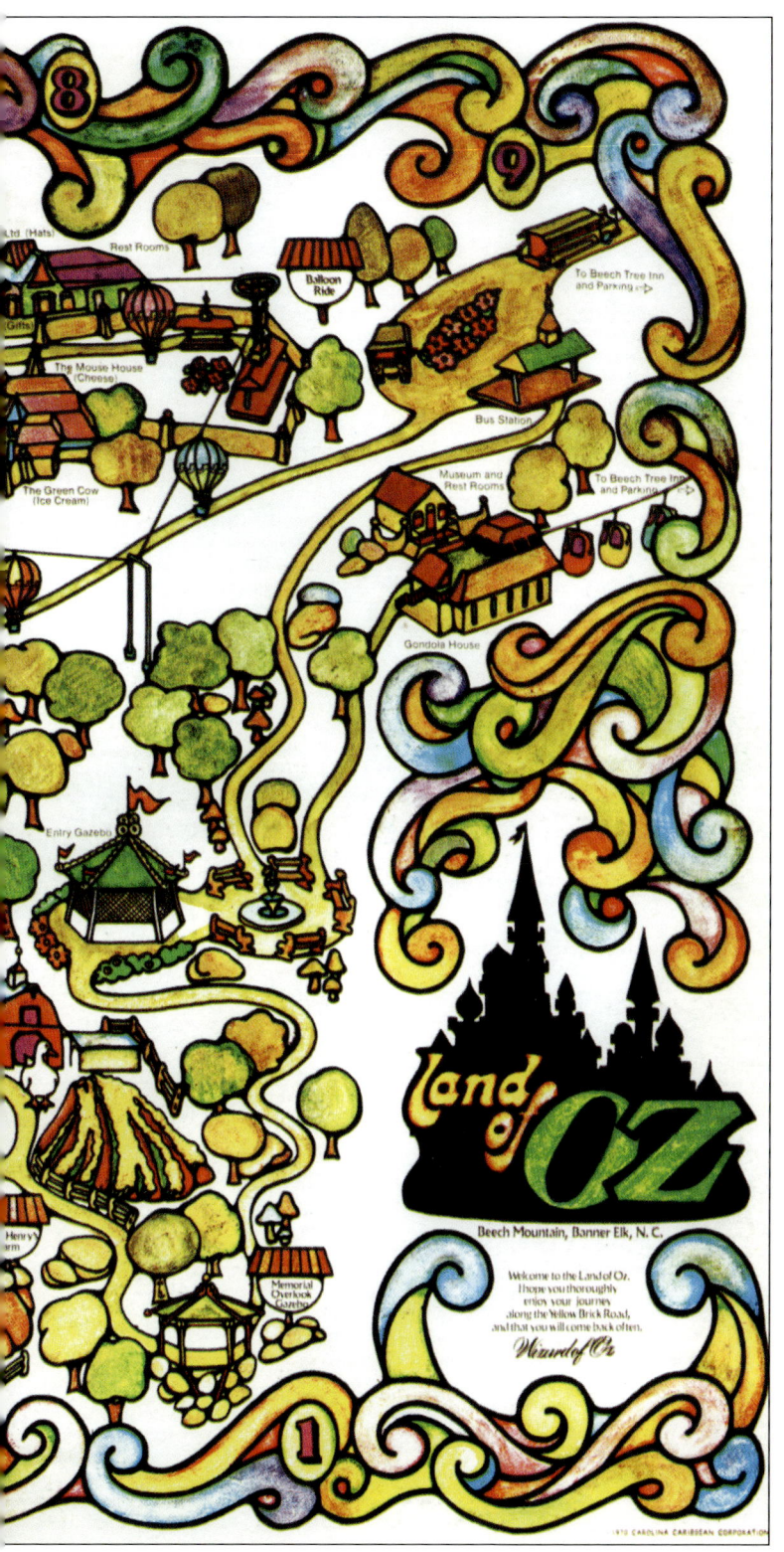

Most theme park souvenir maps were designed to help people navigate their way around the property, but the Land of Oz map was intended to be more graphically attractive than functional. It is by no means drawn to scale. It also shows things that were not usually part of the experience and leaves out other things that were. But if readers so desire, they can use it as they proceed through the following pages and see if they can make sense out of it.

Naturally enough, once off the cantilevered front porch of the wrecked farmhouse, the first thing one saw was the feet of the Wicked Witch of the East protruding from underneath. This definitely is not Kansas—or North Carolina?—anymore. (Jana Greer collection.)

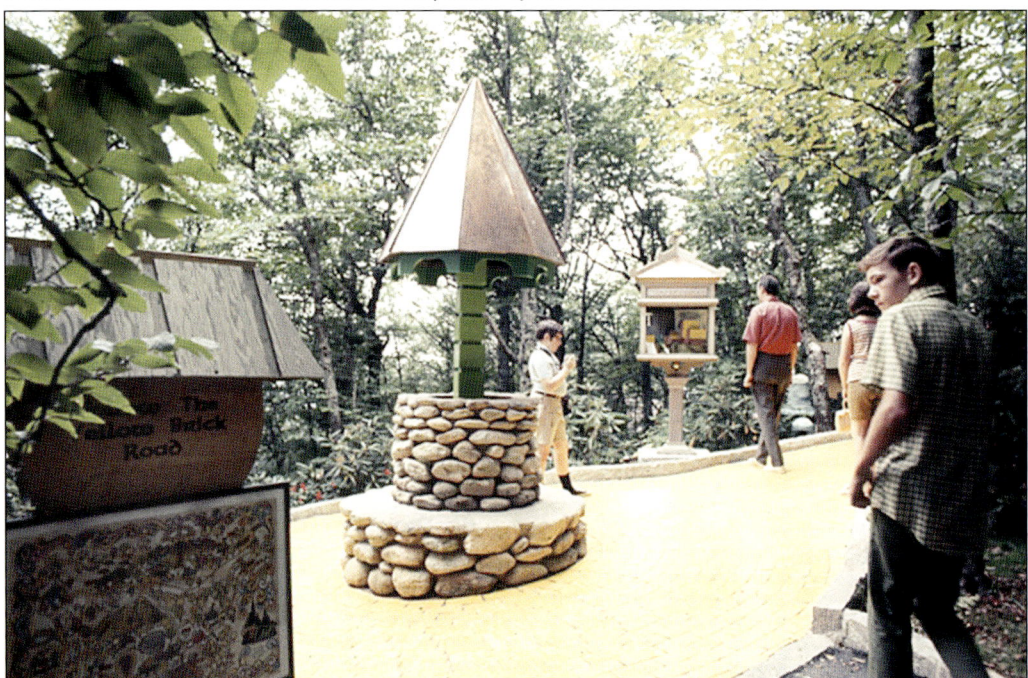

Seen here is the famous Yellow Brick Road, along with a framed copy of the wildly inaccurate park map. This small wishing well was where the journey to the Emerald City truly began. (Rodger Motiska Design, LLC, collection.)

Straight ahead was Munchkinland, where, generally speaking, the tiny houses could be seen but no Munchkins. For some special occasions, the park would dress children in the original Munchkin costumes from the movie, part of Spencer Robbins's haul from the MGM auction. (Chris Robbins collection.)

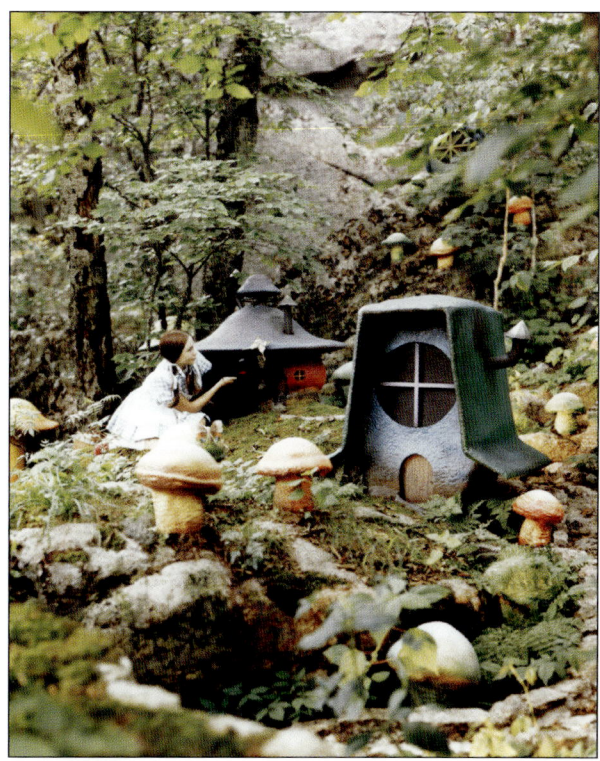

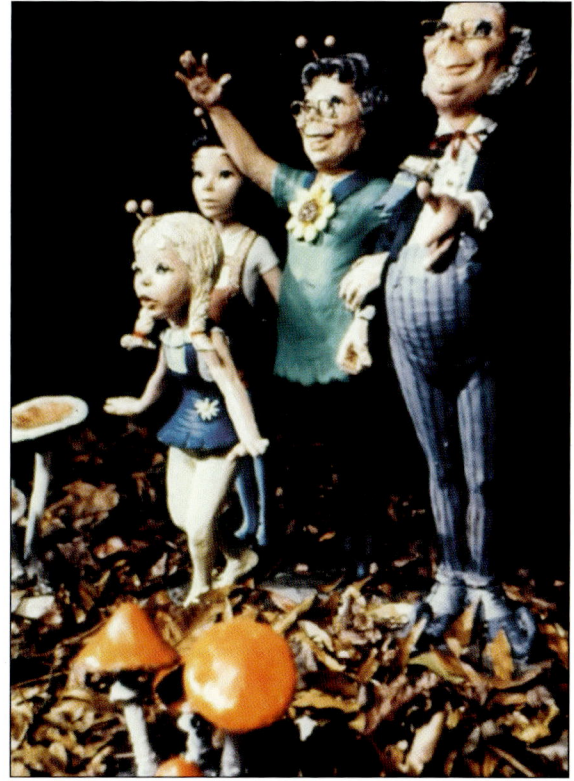

Even though the final version of the park usually had no Munchkins to be seen, during the planning stages, Austin Fox sculpted these models of how the minuscule inhabitants might look. His concept bore an amazing resemblance to Dr. Seuss's famed Whos of Whoville. (Emerald Mountain Realty collection.)

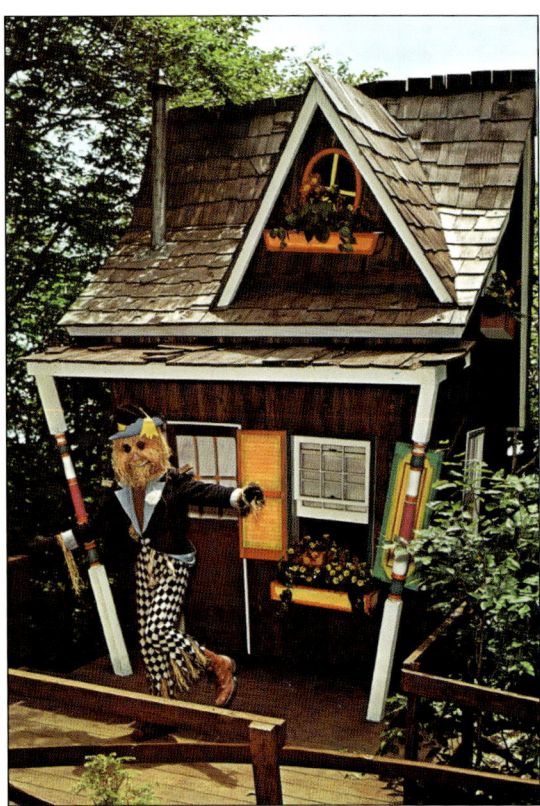

Once out of Munchkin territory, it did not take long to encounter the Scarecrow, who had come up in the world and lived in a house of his own rather than a cornfield. It is obvious that Jack Pentes and his crew did not base this character's appearance on either the book or the movie, with his head seeming to be fashioned from a bale of hay.

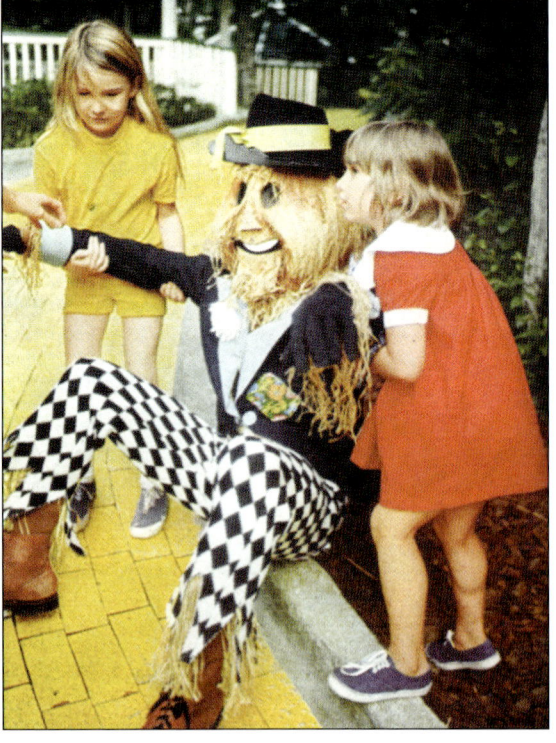

Yes, he's fallen and he can't get up. The original character outfits were created by Brooks Costume Company of New York, and the heads featured moveable mouths that were operated by the wearer via a chin strap. This enabled them to look surprisingly lifelike as they mimed to their prerecorded voice tracks.

The next stop, naturally, was the Tin Woodman's metal dwelling. He performed an energetic tap dance interspersed with funny poems, such as "Of every sport I am a fan / Except the game called Kick the Can!" He ended by creaking his way back inside, explaining, "I have to get up oily in the morning."

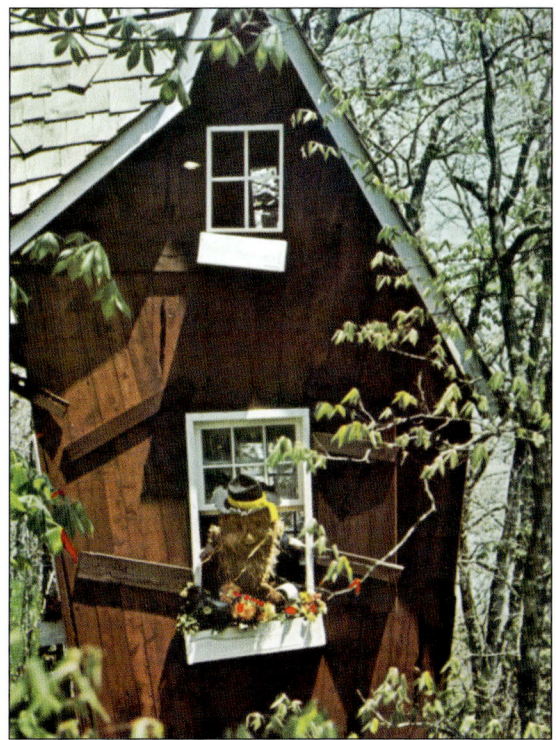

Visitors did not typically get to see this angle showing the side of the Scarecrow's house, but it directly faced the corresponding side of the Tin Woodman's house. During down times, the performers would sometimes participate in fire extinguisher battles between the two structures.

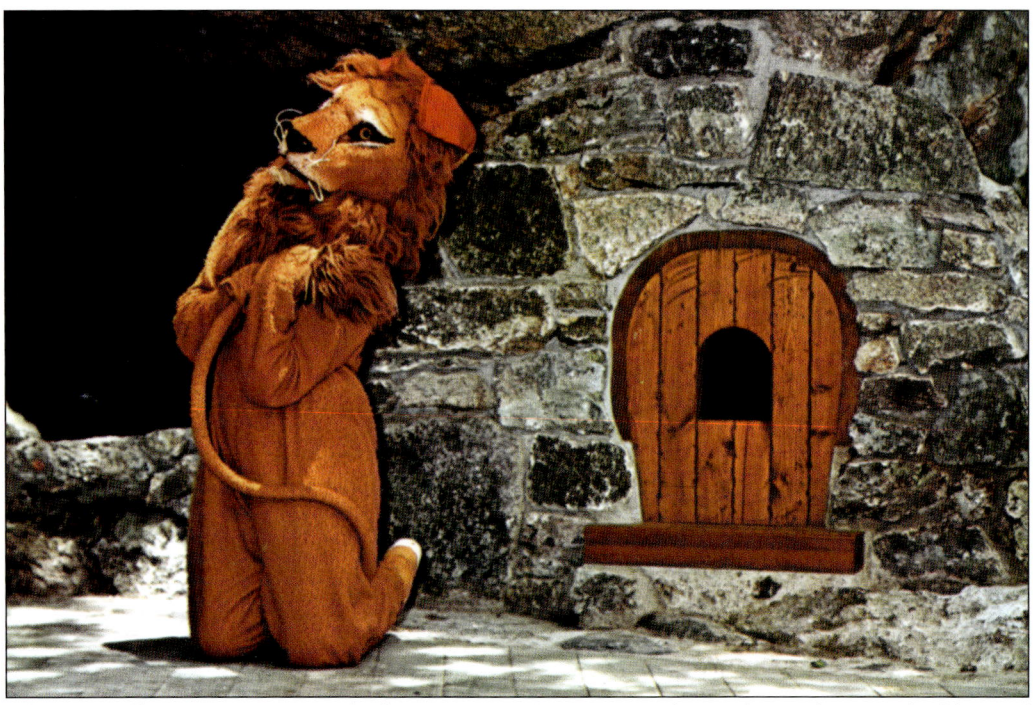

The Cowardly Lion was next on the list, emerging from a natural cave that Jack Pentes had located during his preliminary examination of the property. In his humorous monologue, the not-ferocious feline roared and growled threateningly until being frightened into submission by an itsy-bitsy spider.

A somewhat skeptical-looking tour guide Dorothy and her followers watch the Lion's comical cowardly routine. There was not always a Dorothy on hand to lead groups down the Yellow Brick Road, but when there was, it certainly enhanced the whole experience. (Angie Andrew Blackmon collection.)

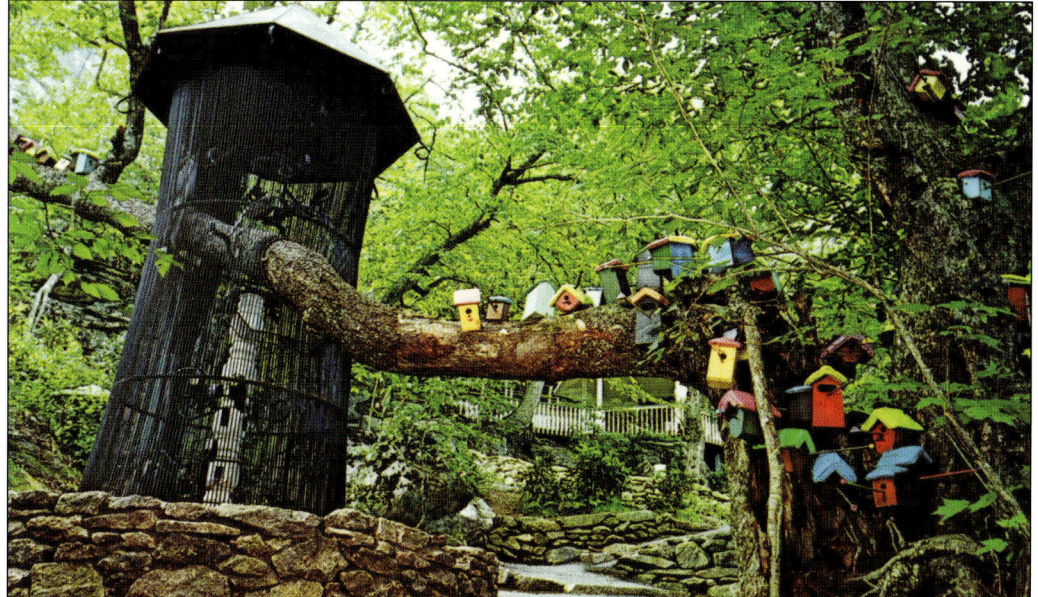

The bird cage, with its live, tweeting inhabitants, and the neighboring Bird House Tree were among those elements of the park that did not directly relate to the story being told but were just there to add to the overall look and feel. Reportedly, Oz's original attempt to adapt tropical birds to a mile-high mountain climate did not end well for the feathered friends.

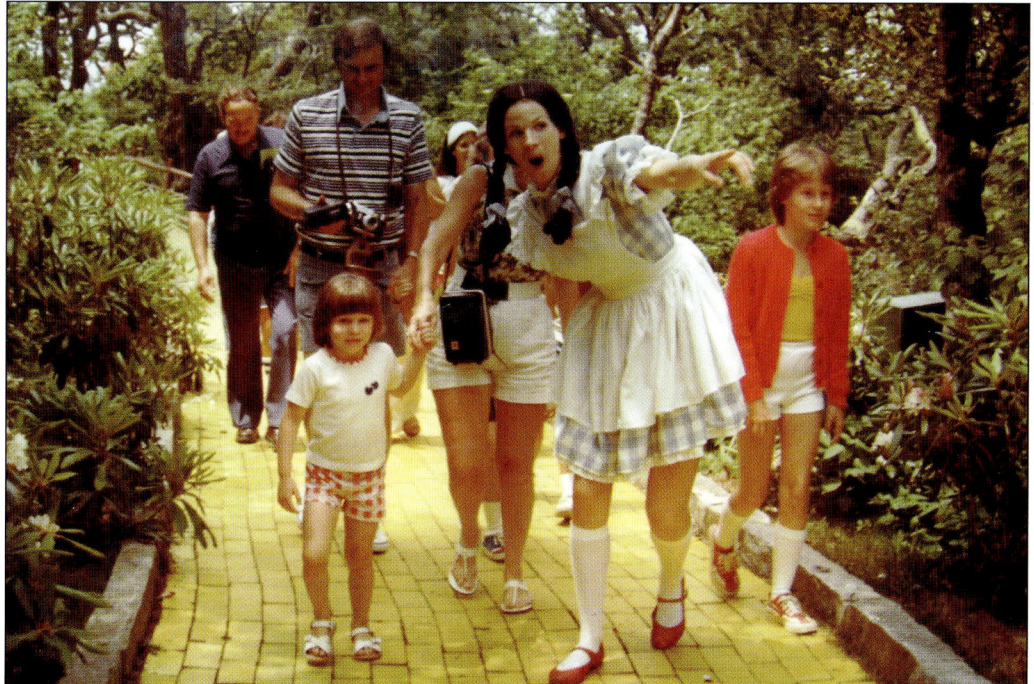

Here is tour guide Dorothy again, and from her expression, it appears that park visitors are about to encounter some more surprising sights. Former park Dorothys agree that the pigtailed wigs they wore made great protection during the almost daily rainfall that was certain to occur atop Beech Mountain. (Emerald Mountain Realty collection.)

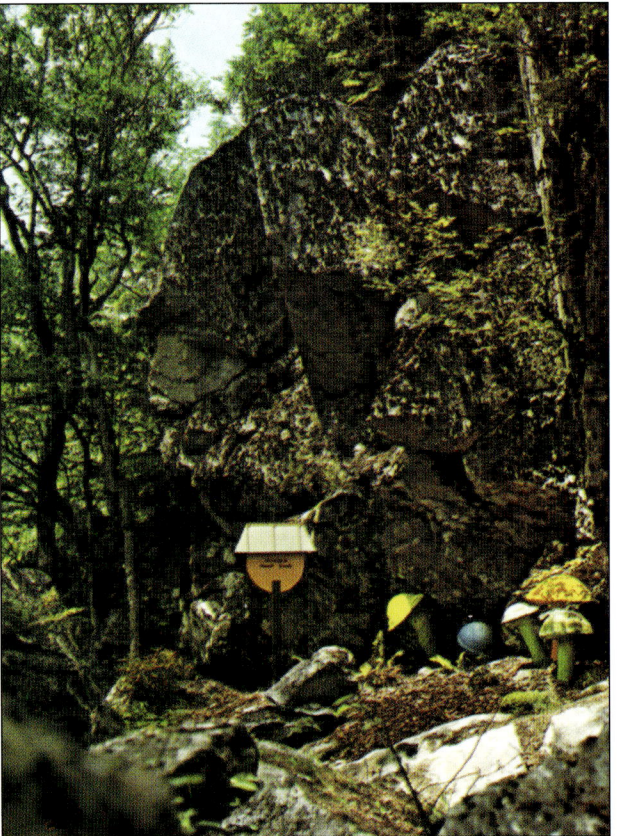

Some tourists did not stop to think how impossible it would be for a waterfall to emerge from the highest peak of a mile-high mountain, so Oz's artificial stream perhaps did not get as much attention as it should have. There was no ignoring the colorful Styrofoam mushrooms that lined the Yellow Brick Road, however, as they were everywhere.

The Witch's Head Rock was promoted as a naturally occurring formation, but there must have been some sort of human enhancement going on. There seems to be no identifiable trace of this old crone's profile today.

And speaking of the Wicked Witch, here she is in all of her ugly glory. Unlike the green-skinned terror portrayed by Margaret Hamilton in the movie, this Oz witch was played for laughs and was far more funny than scary. Notice the old-fashioned auto horn mounted on her broomstick.

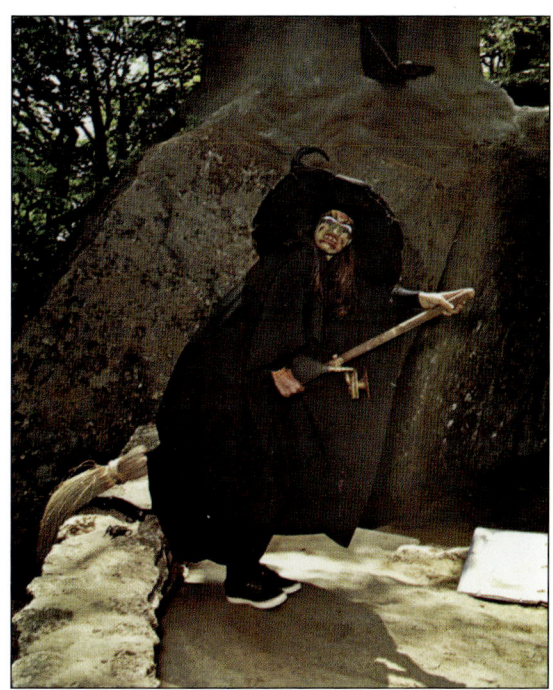

Comparing this image to the one to the right, it becomes obvious that the Wicked Witch's original appearance in 1970 was based heavily on that of the Witchiepoo character from Sid and Marty Krofft's *H.R. Pufnstuf* TV show. It had premiered in September 1969, so it obviously made a convenient blueprint for a non-nightmare-inducing villain.

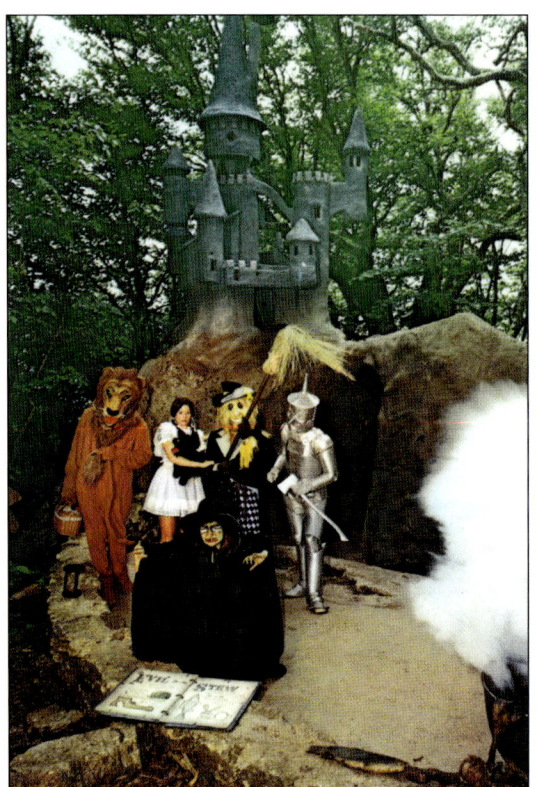

The Wicked Witch's shtick consisted of a comical song, "How Do I Brew This Stew?" She reeled off a list of unlikely ingredients but then seemed more surprised than anyone when her poison potion blew up in her face.

This colorful three-fold brochure spread from the mid-1970s shows, among other unusual images, a slightly later version of the Wicked Witch. It does not appear that her rubber nose is fooling anyone, but her arms and hands look like she might have regressed to around 16 years old.

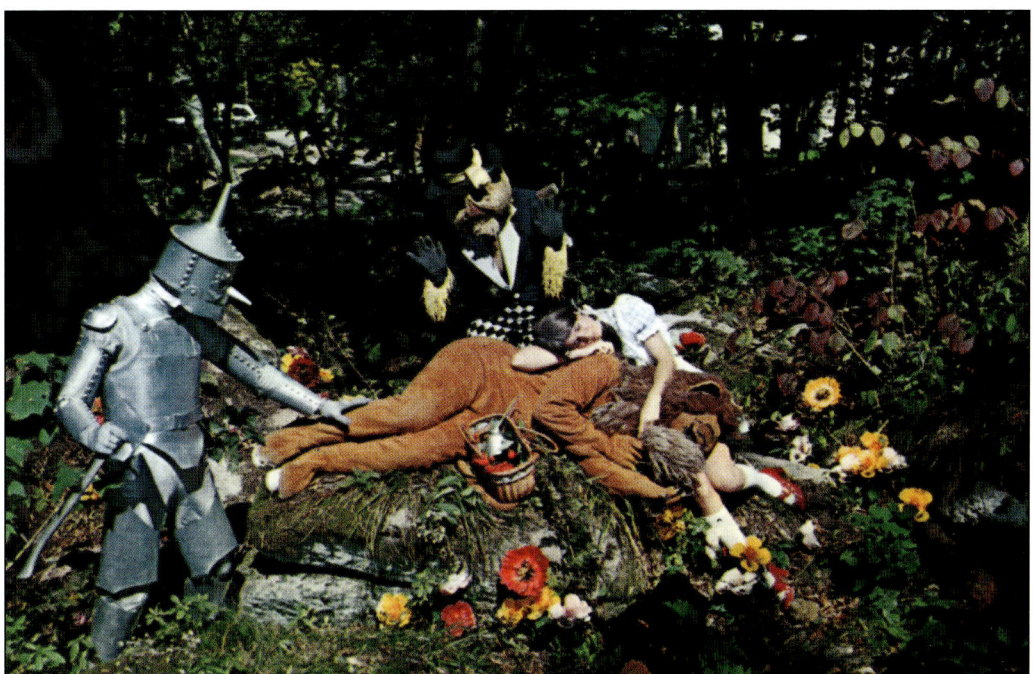

The infamous Poppy Field was one of the sights that came and went over the years. For this shot, notice that the Lion's face is partially covered to camouflage the fact that the costume's eyes could not close. Baum went to the trouble to explain that the Scarecrow and Tin Woodman were not affected by the poppies because they did not breathe, but in the movie, no particular reason was given.

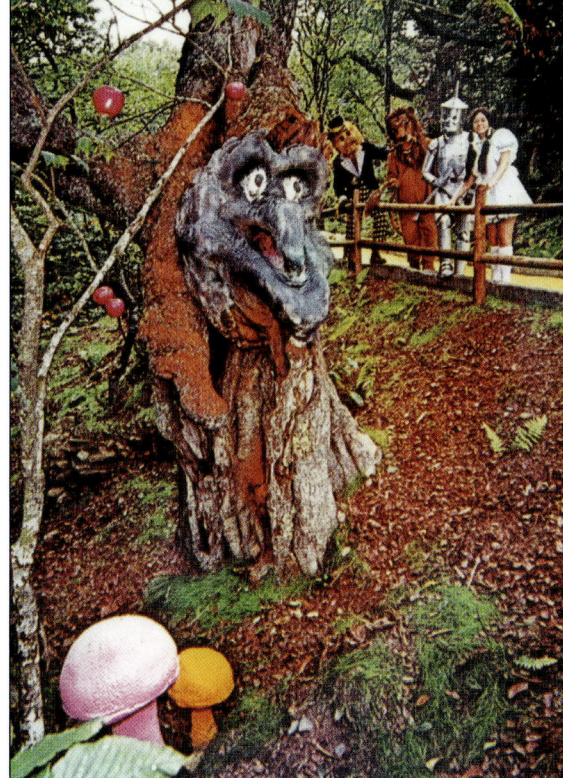

The souvenir map back on pages 24–25 indicated "Apple Trees" as one of the final sights before reaching the Emerald City. Actually, this single apple tree was one of the most photographed sights in the park. Later photographs show no plastic apples attached, only its appealing, jolly face.

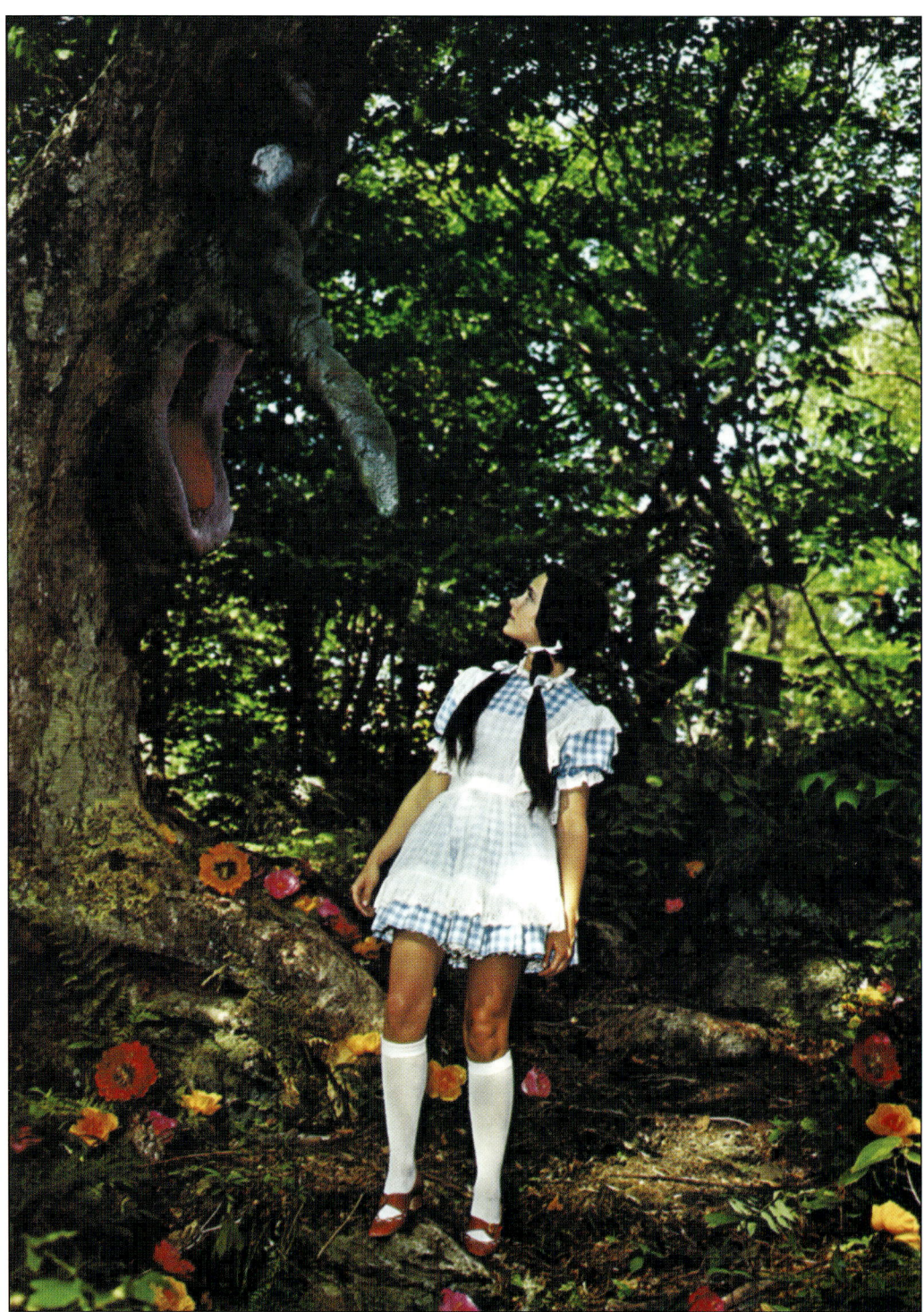

The early-1970s Land of Oz was a great place for fans of the miniskirt, and most of the Dorothys wore it well. Back to the subject of the humanized trees, while certain natural protruding pieces were used, the majority of the faces were created from the same Styrofoam as the colorful mushrooms.

Three

THE EMERALD CITY

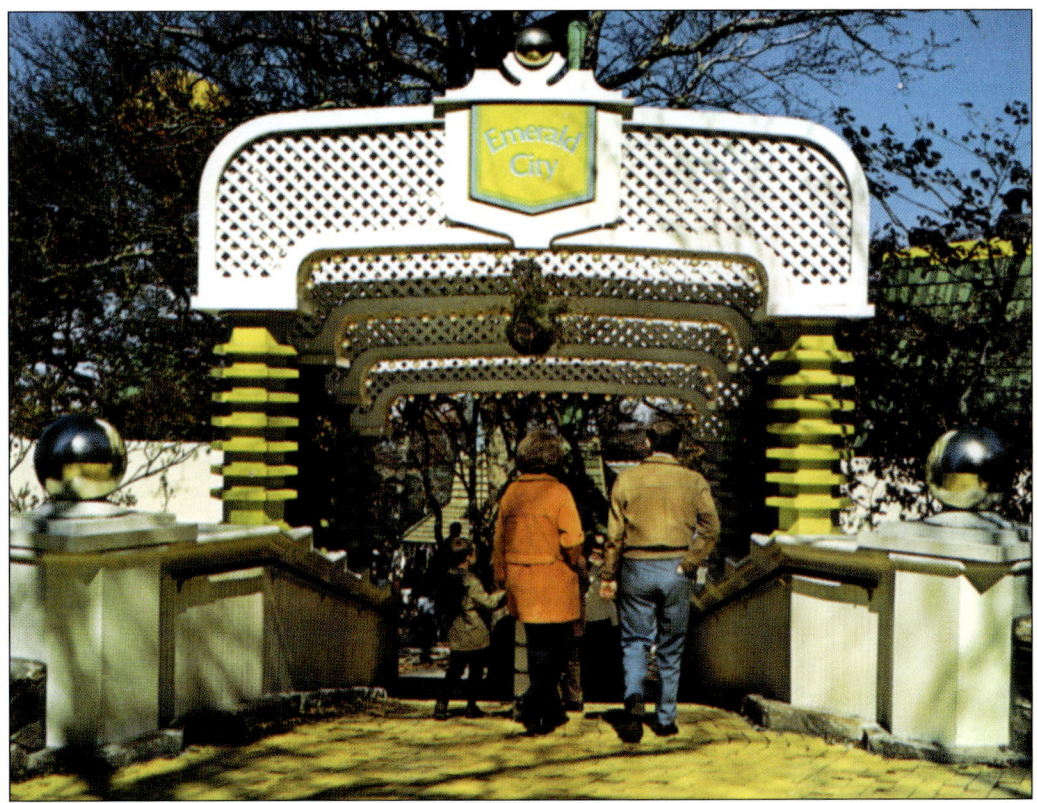

Well, it's here at last! Here, at the end of the Yellow Brick Road, is the gateway to the Emerald City, without a grumpy guard in sight. Although various shades of green were used, to remain faithful to its name, there were enough swatches of other colors to keep things from looking too monochromatic.

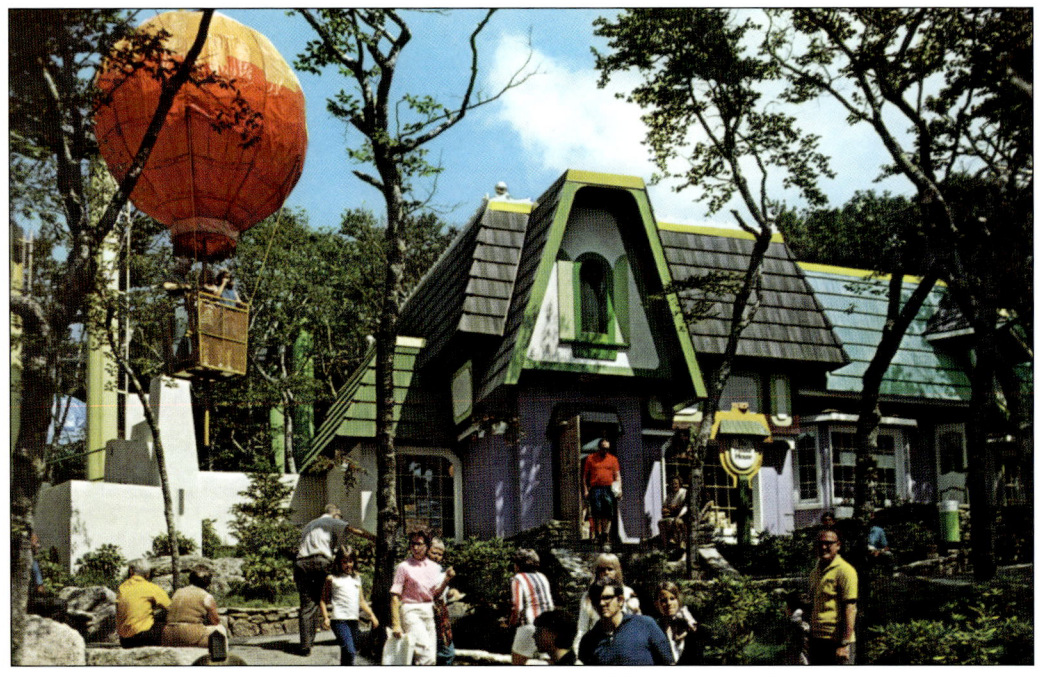

The Emerald City was probably the part of the Oz experience that most closely resembled what visitors had come to expect from a traditional theme park. Restaurants and gift shops were clustered closely together, and the park's only ride was part of this section as well—but more on that a little later.

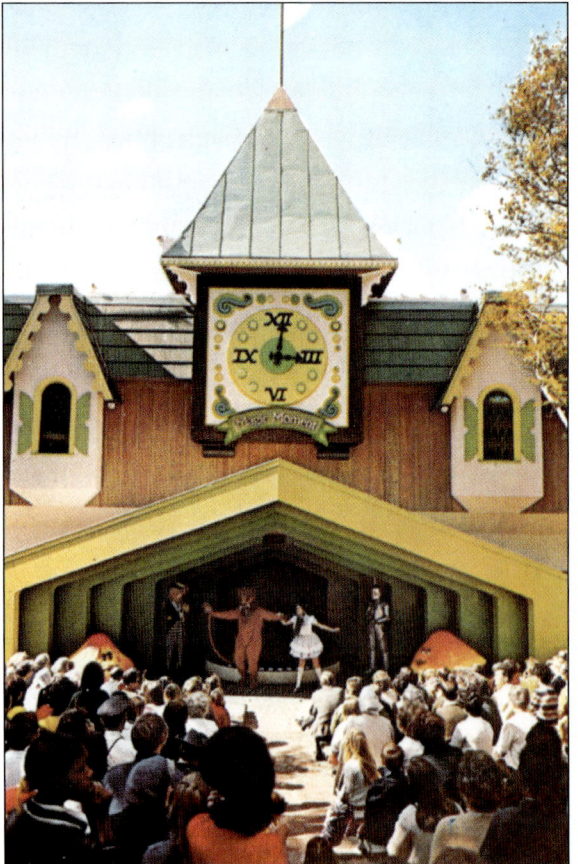

The focal point of the Emerald City was the Magic Moment stage show, set to a magnificent musical soundtrack by North Carolina composer Loonis McGlohon. This is where the characters who, up to that point, had only been seen separately along the Yellow Brick Road finally got together to demand an audience with the Wizard.

Jack Pentes and his staff created some new characters for the Magic Moment show, chiefly a green mouse named, appropriately, Mr. Greenie. He served as the Wizard's majordomo, reluctantly allowing Dorothy and company to bother the great man.

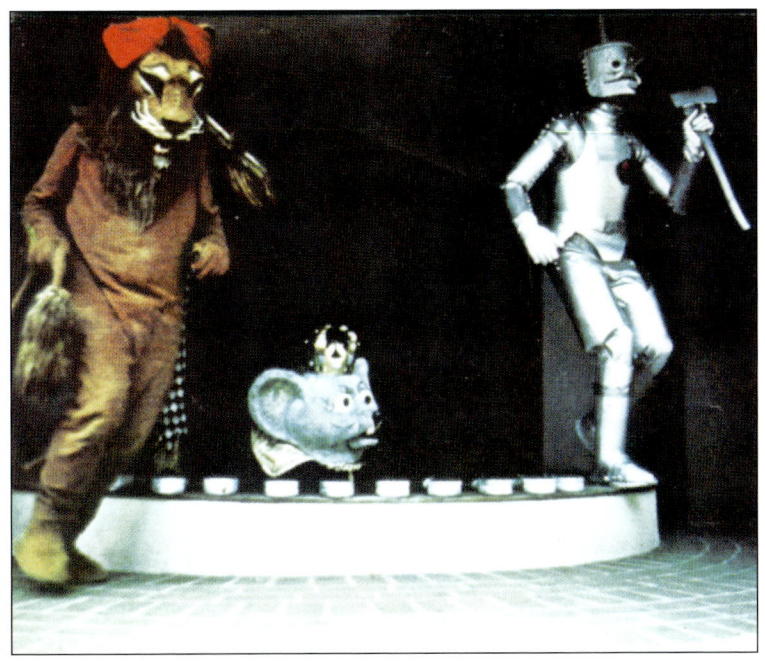

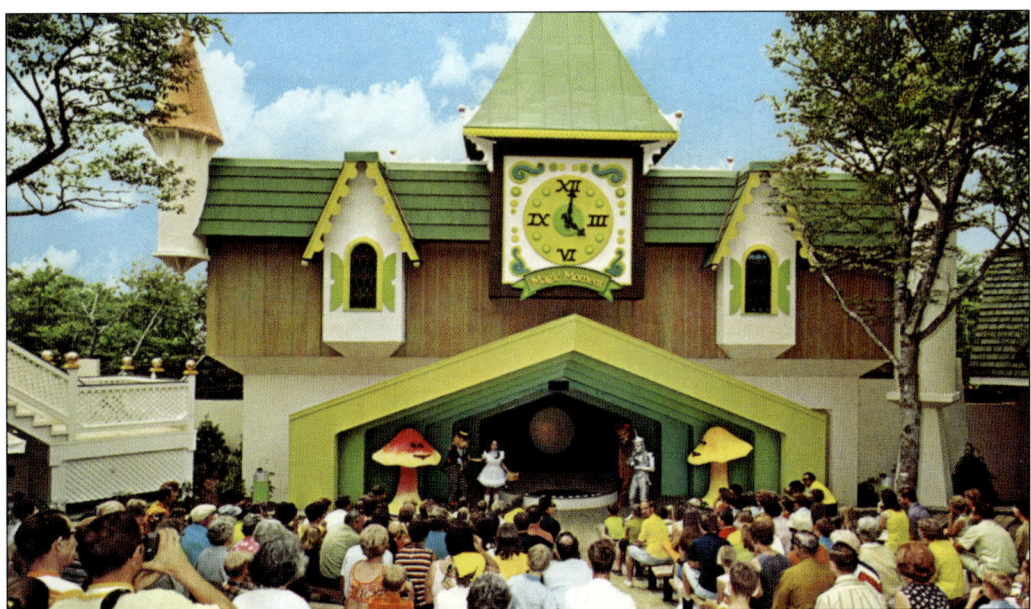

Like the Witchiepoo-inspired Wicked Witch, the Magic Moment show's Dancing Mushrooms also seemed to have a bit of *H.R. Pufnstuf* influence behind them. In this production, the Wizard appeared only as a rear projection image on a screen, bellowing out his displeasure at being disturbed.

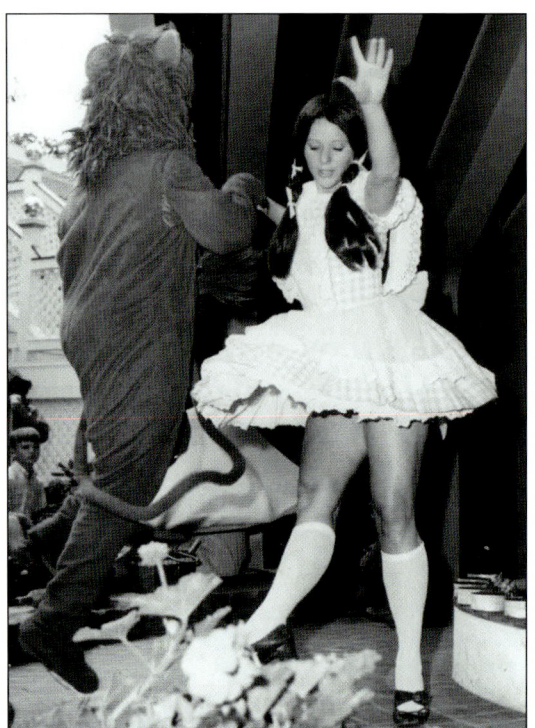

All of the dance routines in Oz were the work of Alice Leggett LaMar, who counted herself as a true fan of the original 40-book Oz series. She described her job as "rather like super make believe, in which your dolls really walk and dance." (Emerald Mountain Realty collection.)

A few pages ago, the almost daily rainfall at Beech Mountain's elevation was alluded to. The show went on, rain or shine, although as can be seen from this soggy shot, during certain downpours, the audience would be forced to abandon the theater seats for drier ground.

The climax of the Magic Moment show came when Dorothy would lip-sync to Loonis McGlohon's terrific orchestral arrangement of "Over the Rainbow," the only song in the park that was licensed from MGM. Dorothy is also rocking that miniskirt again.

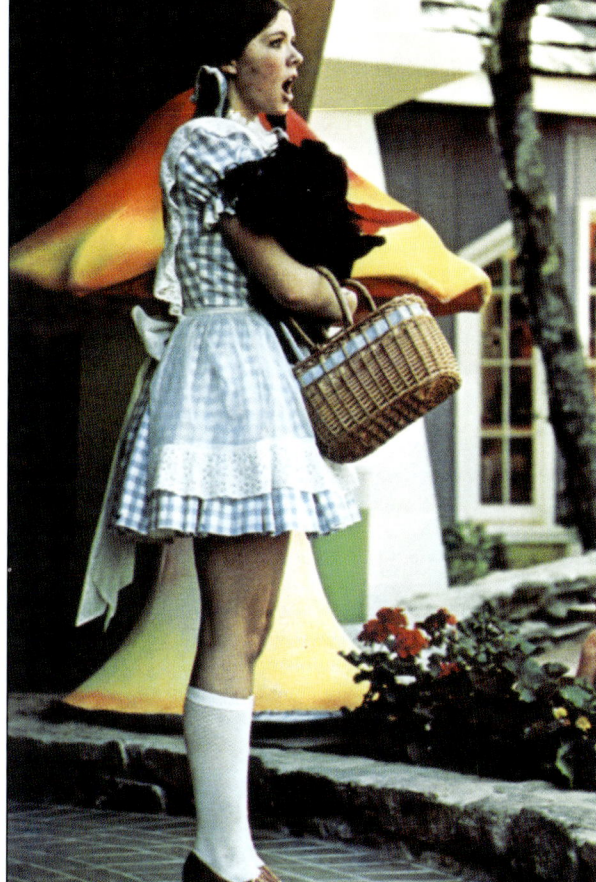

In this version of the story, the Wizard was not revealed to be a phony, nor were Dorothy's red shoes given any sort of alleged magical powers. Instead, at the very end of her solo, she simply vanished from the stage in an enormous puff of smoke.

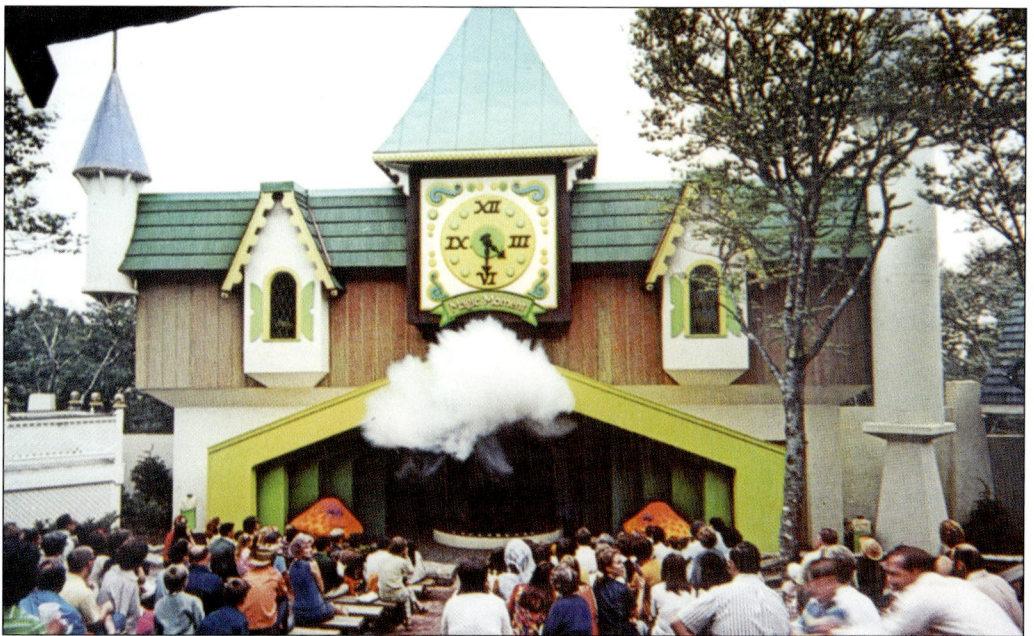

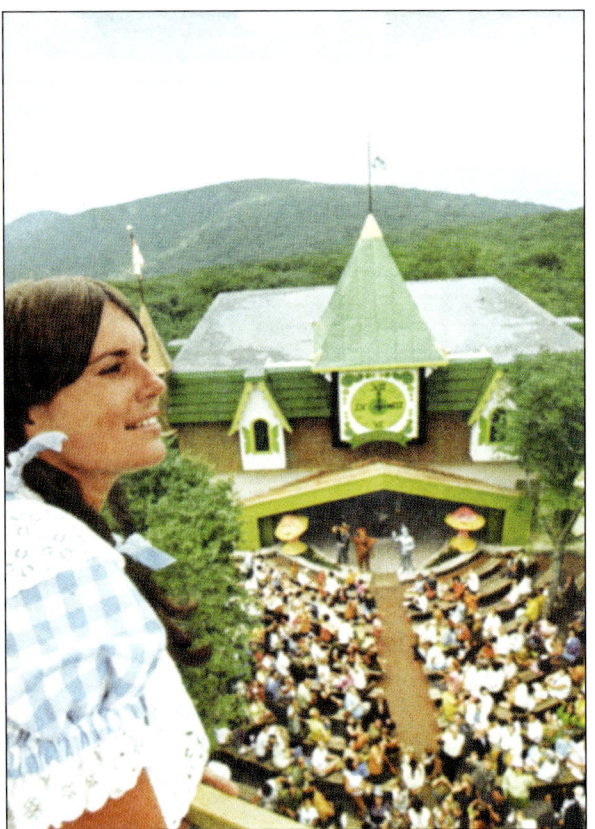

At the same moment Dorothy disappeared from the stage, the audience heard her calling goodbye from somewhere above and behind them. There she was, in one of the Wizard's hot air balloons, on her way back home to Kansas—or North Carolina—or wherever else was no place like home. (Emerald Mountain Realty collection.)

Since other guests were riding in the balloons before and after the Dorothy double, she had a unique way of concealing her presence until the crucial moment. Balloon Dorothy would wear a raincoat and hood and then, on cue, throw them off like Clark Kent turning into Superman. Once out of sight of the audience, she would revert to the "covered up" look as she made her way back to the ride's starting point.

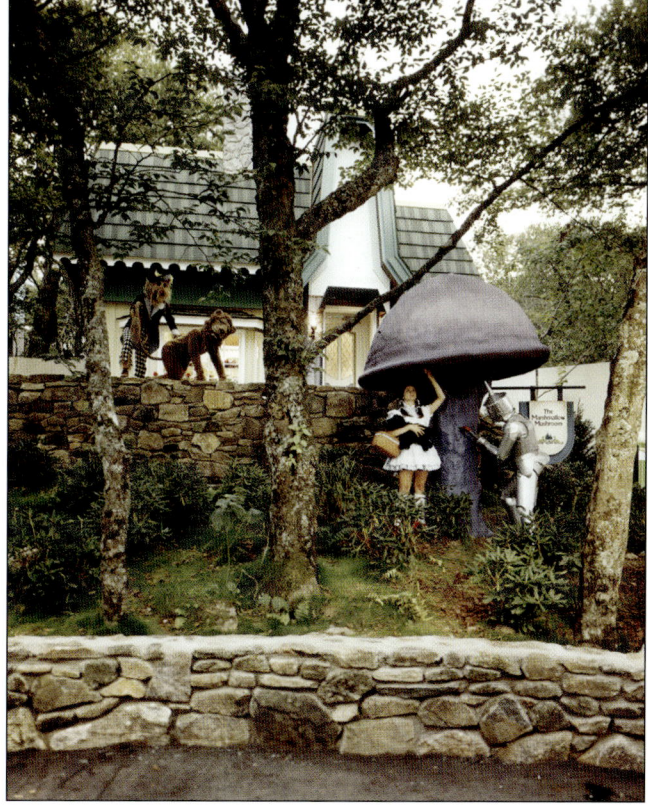

The only true restaurant in the Oz park was the Rainbow Restaurant, situated conveniently just to the left of the theater. Unless one was a Scarecrow or a Tin Woodman, who could not eat any easier than they could breathe, one had probably worked up quite an appetite by that time. (W.L. Eury Appalachian Collection, Appalachian State University.)

Oz's continuing fascination for umbrella-shaped fungi was evidenced by the candy shop known as the Marshmallow Mushroom. Here, Dorothy seems to be testing the advice of her cousin, Alice in Wonderland, by figuring out which side will make her grow larger—maybe to enable her to handle her farm chores more efficiently. (Chris Robbins collection.)

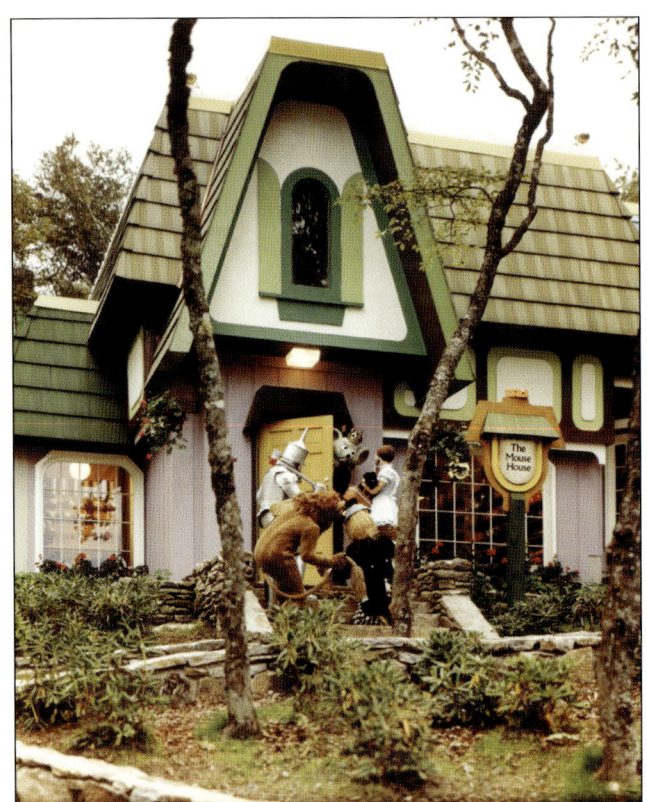

For at least one publicity photograph, Greenie the mouse left the Wizard's throne room to promote the Mouse House gift shop. Naturally enough, it specialized in various imported cheeses, somewhat like the chain of Hickory Farms stores, one suspects. (Chris Robbins collection.)

The Munchkin Shop, according to the park map, was a doll store. Looking closely at those strange, green-skinned creatures guarding the front entrance, one may wonder what sort of creepy dolls waited inside. (Chris Robbins collection.)

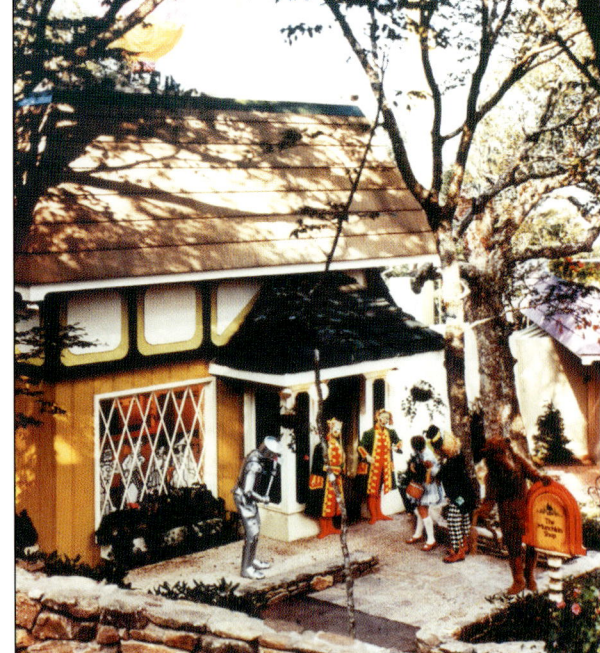

To the immediate right of the stage were Lids, Ltd. (selling hats, naturally) and the Tin Smitty souvenir shop. If one were not in the market for headgear, the Tin Smitty sold copies of the original 14 Oz books by L. Frank Baum, so everyone could read how the whole thing started. (Chris Robbins collection.)

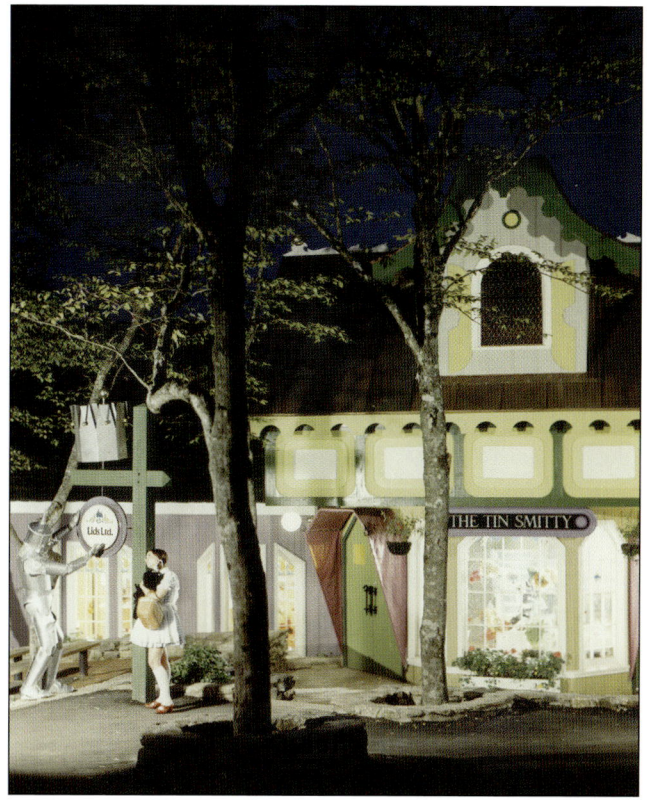

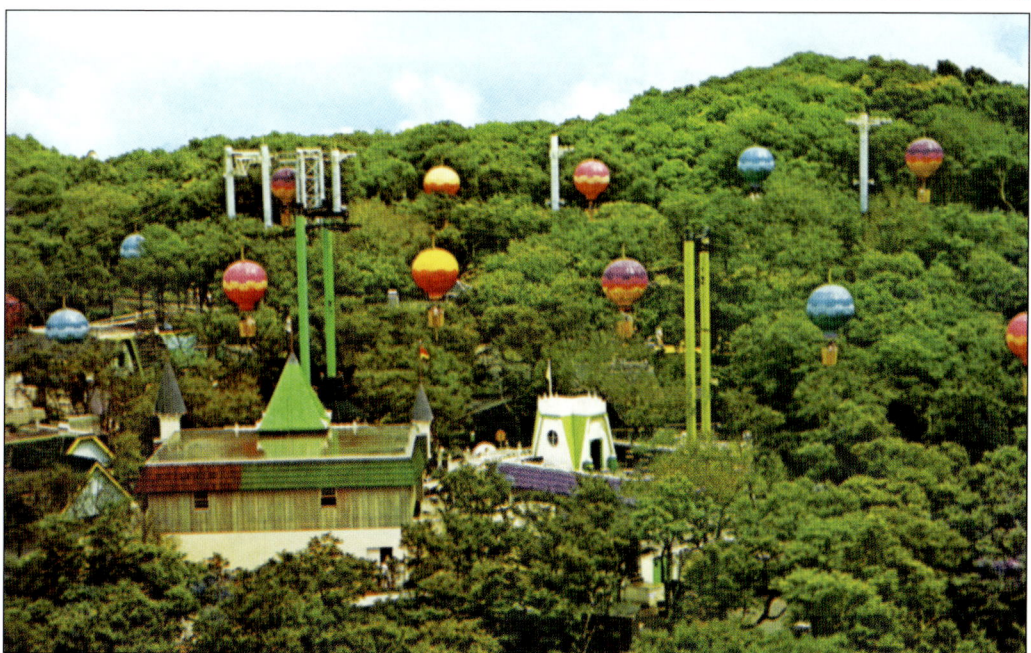

As mentioned earlier, the simulated hot air balloons were the only ride in the entire Oz park. Built by a North Carolina company, they were modeled on a standard ski lift mechanism and took visitors on a scenic ride over the rooftops and trees.

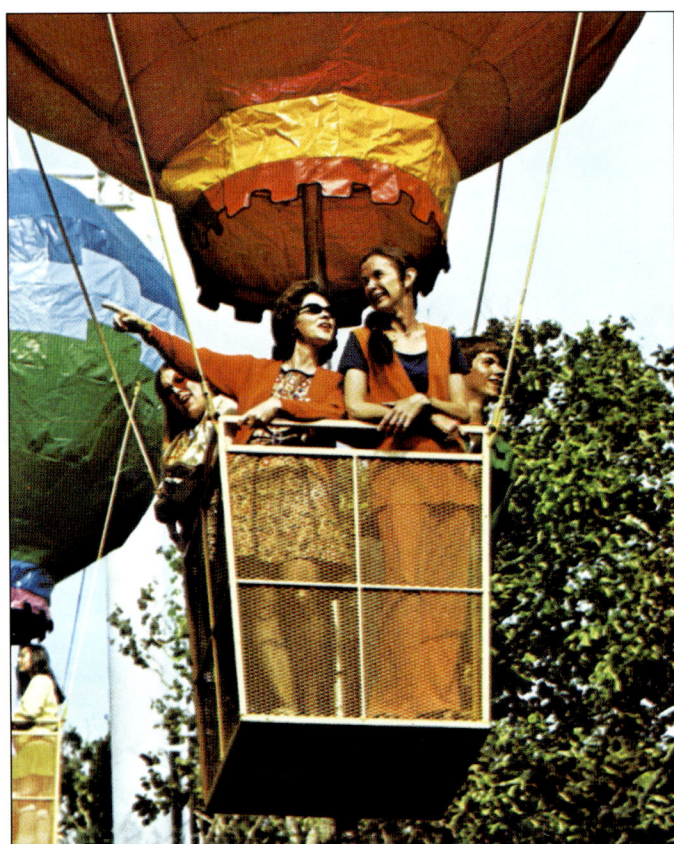

In this posed view, the lady in the blue shirt and red vest is the aforementioned choreographer Alice Leggett LaMar, taking time out from her musical duties to enjoy the view from the balloon ride. She says this was one of the very few times anyone talked her into boarding one of the swinging gondolas, as she preferred remaining earthbound.

This incredible aerial view of the Land of Oz was certainly one that was not part of a normal visit. From this altitude, the entire property can be seen, including the Memorial Overlook gazebo, the farm, the Yellow Brick Road, and the balloon ride. The rocky outcropping in the lower center part of the photograph is the actual summit of Beech Mountain, 5,506 feet above sea level.

Four

HOW ABOUT A LITTLE FIRE, SCARECROW?

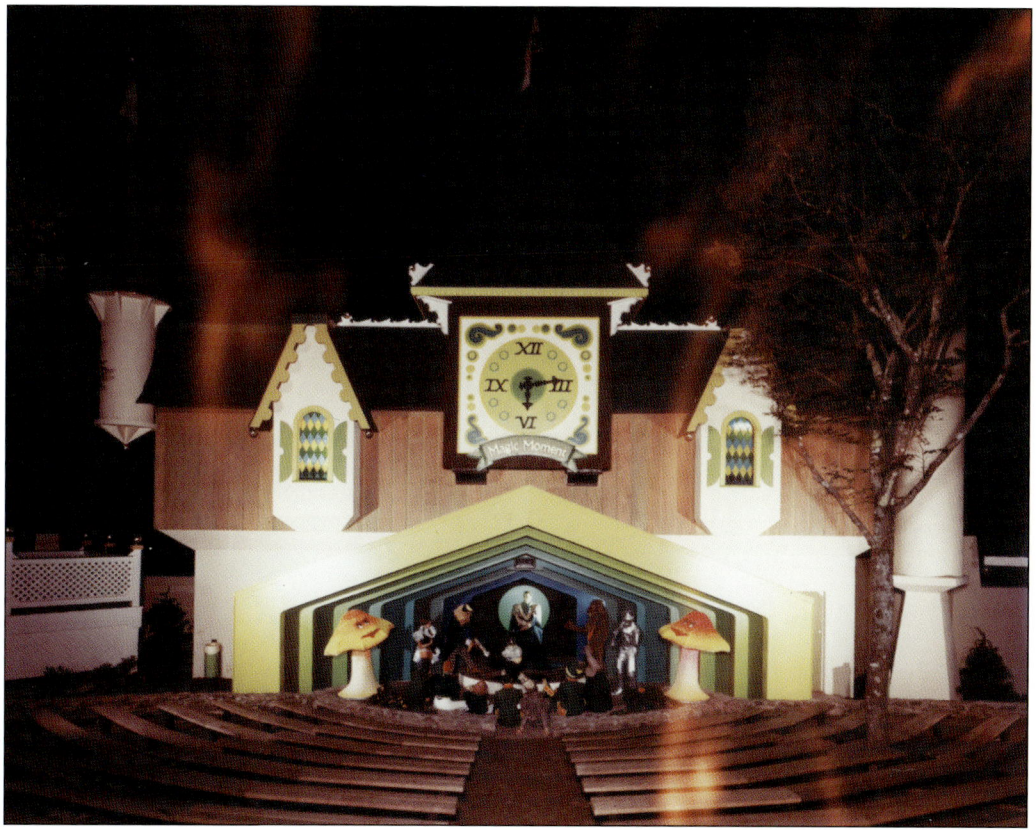

The turning point in Land of Oz history came on the night of December 28, 1975. A devastating fire swept through the theater and the adjoining gift shops, destroying much of the park's material that was in storage for the winter months. There were initial doubts that it would be able to reopen. (Chris Robbins collection.)

As soon as winter loosened its grip on Beech Mountain, the rebuilding of the theater, as well as the heavily damaged gift shops, got underway. Although the exact cause of the fire was never determined, the general opinion held that it was a part of a botched attempt to steal the MGM movie costumes and props, which were, of course, in storage for the off-season. However, the only item missing turned out to be the gingham Judy Garland dress. (Both, Emerald Mountain Realty collection.)

Also destroyed in the fire were the original character costumes. Perhaps reflecting the public's changing perception of Oz, the new costumes that made their debut in 1976 much more closely resembled the movie characters. The Scarecrow, Tin Woodman, and Cowardly Lion now wore face paint rather than giant heads, and Dorothy's former miniskirt was no longer in style.

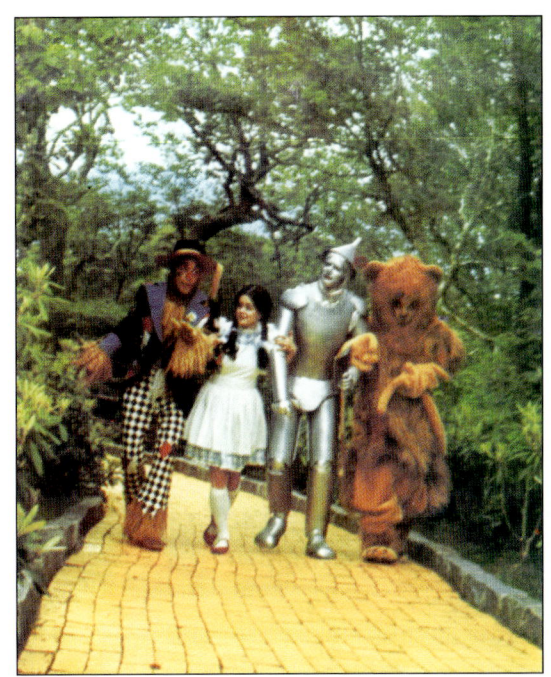

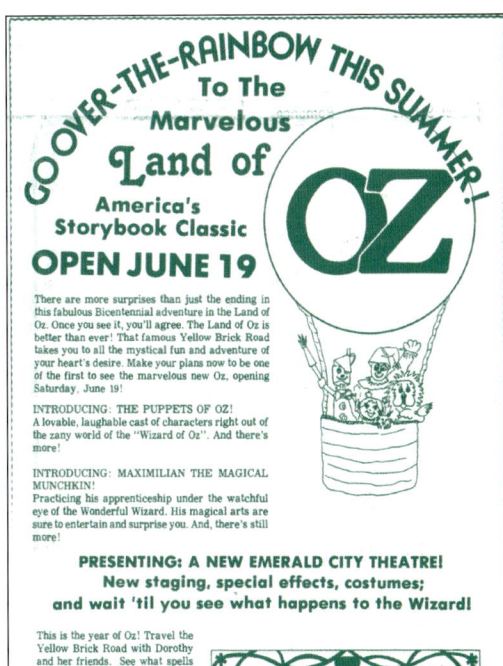

The grand reopening of Oz on June 19, 1976, was the cause of much celebration. This ad, or variations of it, ran in dozens of North Carolina newspapers large and small. It mentions many of the revamped, or sometimes completely new, elements that were in place to change the entire Oz experience. (Emerald Mountain Realty collection.)

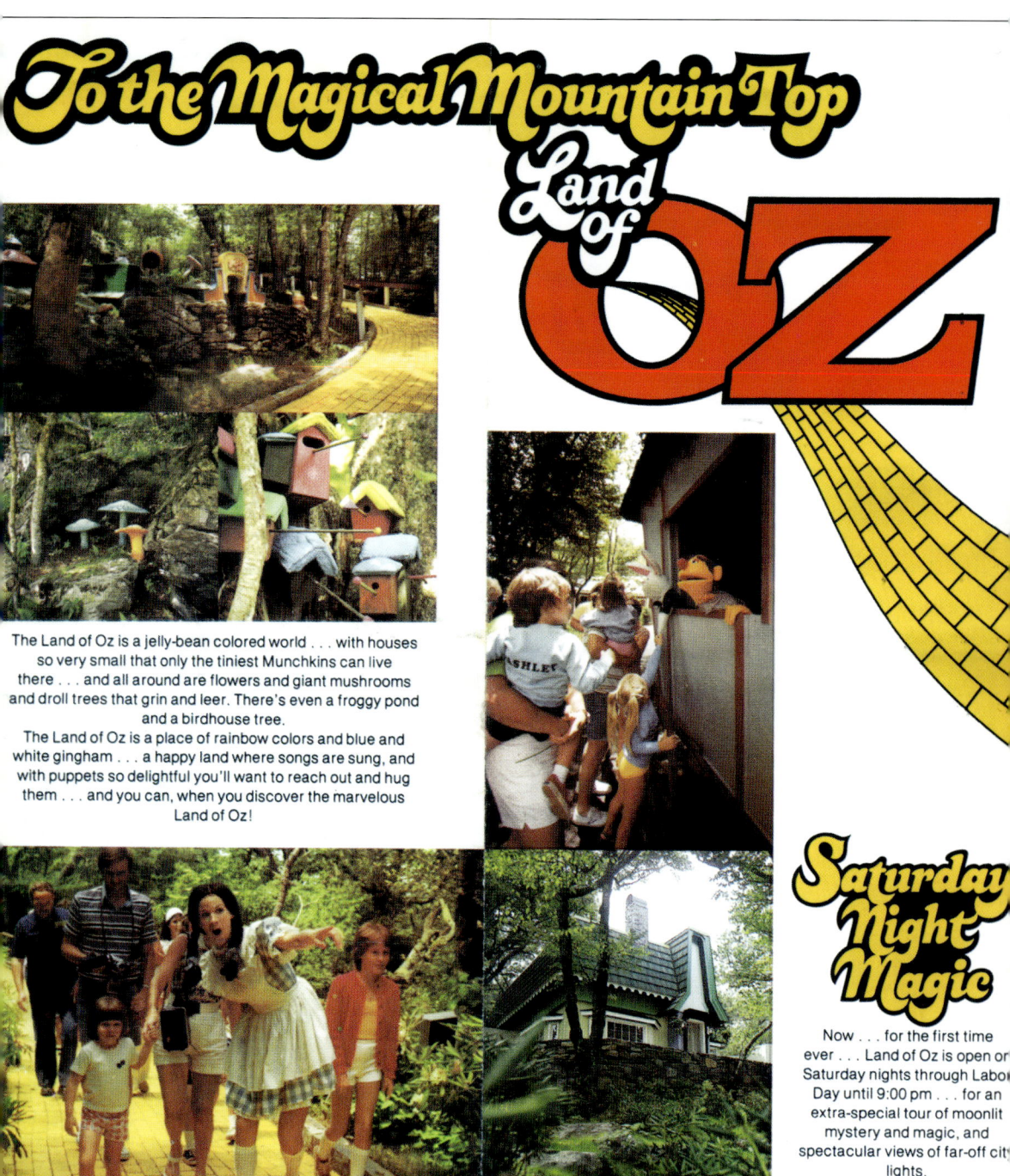

To the Magical Mountain Top Land of Oz

The Land of Oz is a jelly-bean colored world . . . with houses so very small that only the tiniest Munchkins can live there . . . and all around are flowers and giant mushrooms and droll trees that grin and leer. There's even a froggy pond and a birdhouse tree.

The Land of Oz is a place of rainbow colors and blue and white gingham . . . a happy land where songs are sung, and with puppets so delightful you'll want to reach out and hug them . . . and you can, when you discover the marvelous Land of Oz!

Saturday Night Magic

Now . . . for the first time ever . . . Land of Oz is open on Saturday nights through Labor Day until 9:00 pm . . . for an extra-special tour of moonlit mystery and magic, and spectacular views of far-off city lights.

The new look of Oz is best represented by the 1976 brochure, which gives ample space to the new character costumes. It also points out another new concept: on Saturday nights, the park

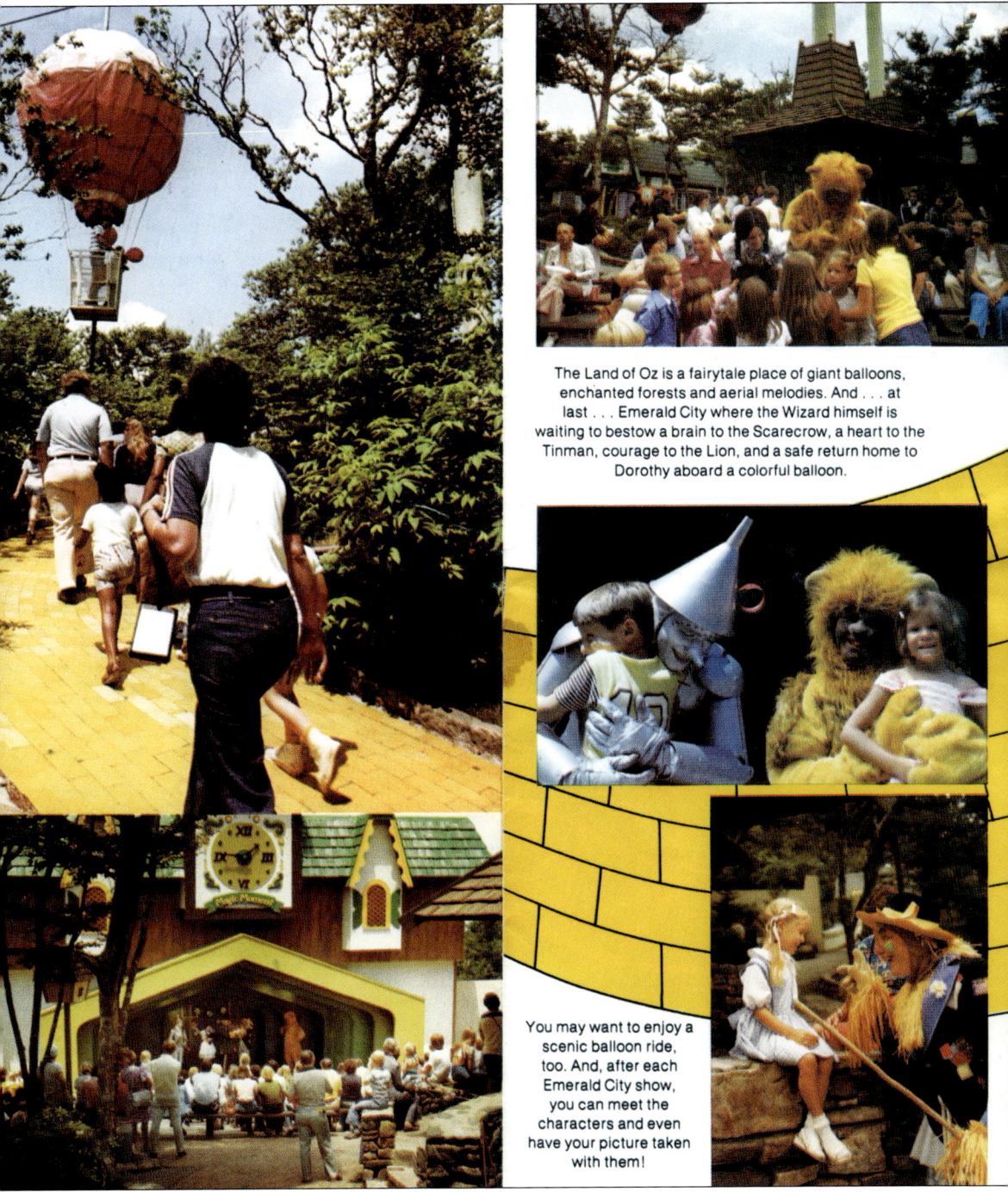

The Land of Oz is a fairytale place of giant balloons, enchanted forests and aerial melodies. And . . . at last . . . Emerald City where the Wizard himself is waiting to bestow a brain to the Scarecrow, a heart to the Tinman, courage to the Lion, and a safe return home to Dorothy aboard a colorful balloon.

You may want to enjoy a scenic balloon ride, too. And, after each Emerald City show, you can meet the characters and even have your picture taken with them!

would be open until 9:00 p.m. It had never before been regularly accessible to the public on an after-dark basis.

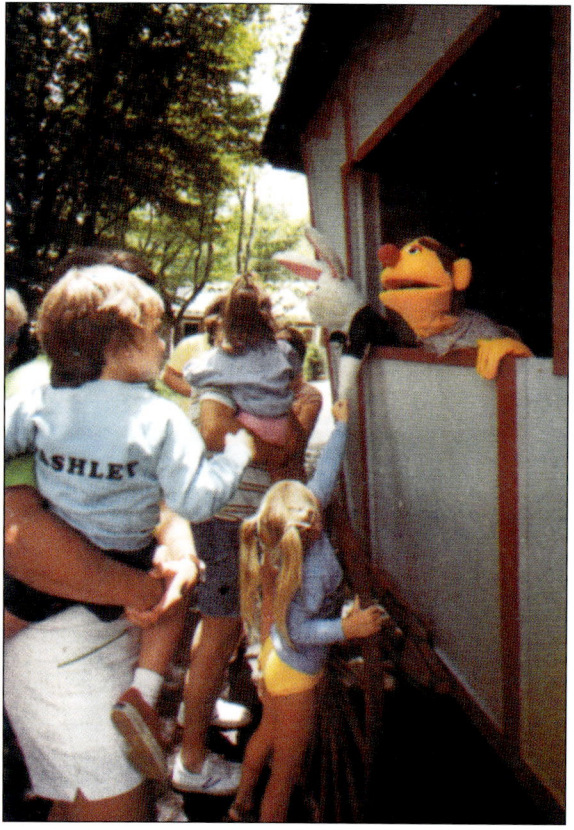

Faced with the fact that tourists of 1976 expected more out of a theme park than they had in 1970, several features were added. One of these was Professor Marvel's Puppet Show, performed out of a wagon parked on the trail that led to Uncle Henry's farm. The puppets looked like the same type that could be found in any children's church of the era, but their ad-libbed banter with guests was at least one way to increase entertainment value (and, simultaneously, keep guests on the property longer). (Above, W.L. Eury Appalachian Collection, Appalachian State University.)

Obviously, the park brochures had to be redesigned to replace any depictions of the pre-fire costumes with the new look. Compare this artwork to the photograph of the characters on page 49; one can see just how different they were from their original 1970 designs.

The Gale farmhouse now had a host who would knock on the door when it was time for a tour to begin. Dorothy would then emerge to greet her visitors and lead them into her home. The trip through the storm cellar and tilted version of the house remained pretty much as it had been. (Angie Andrew Blackmon collection.)

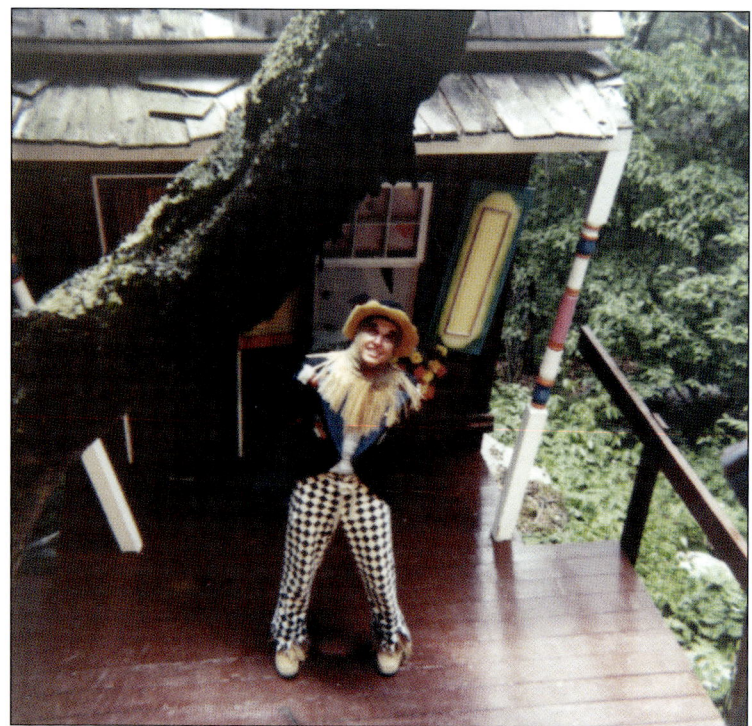

Since the characters' prerecorded dialogue tapes had also been destroyed in the fire—and they were getting pretty worn out from six seasons of usage anyway—new routines were recorded to be performed at their stations. The Scarecrow's coat and pants retained much of their early-1970s look to give some continuity to the park. (Angie Andrew Blackmon collection.)

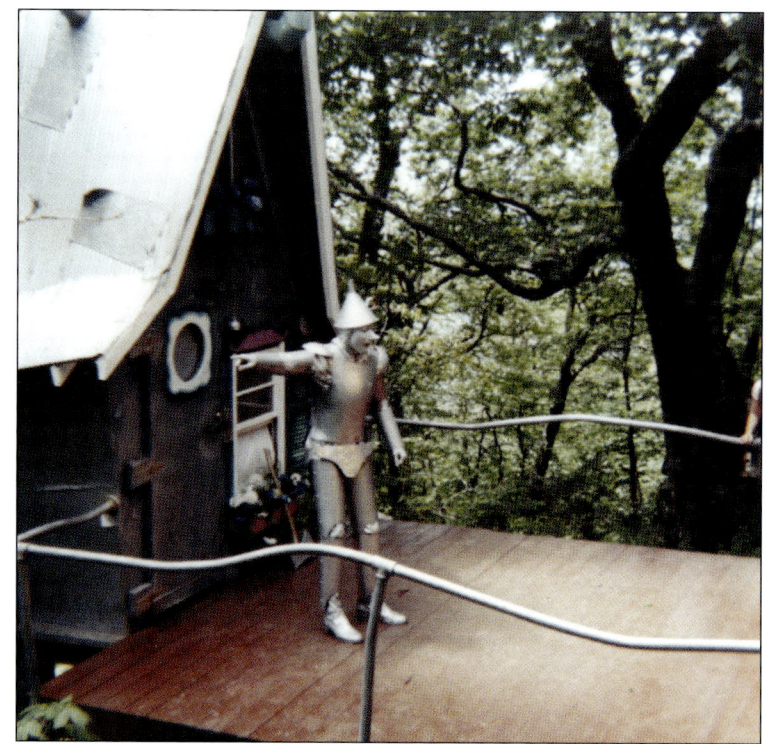

It is not certain just what the Tin Woodman is trying to point out in this photograph—the Cowardly Lion's cave is in the other direction. (Angie Andrew Blackmon collection.)

The Cowardly Lion costume changed at least twice after the fire. The first version, which resembled a giant teddy bear, has already been seen. Here is the feline's look for 1977, when he was based much more closely on Bert Lahr's movie portrayal. (Angie Andrew Blackmon collection.)

Perhaps the biggest changes involved the Magic Moment show in the Emerald City. It was completely revamped by theater professor Allen Lyndrup and lasted approximately twice as long. It now featured a prologue involving more puppets, who humorously set up the story by worrying about the "little girl wearing red shoes" who was rapidly approaching from the direction of the witch's castle. (Emerald Mountain Realty collection.)

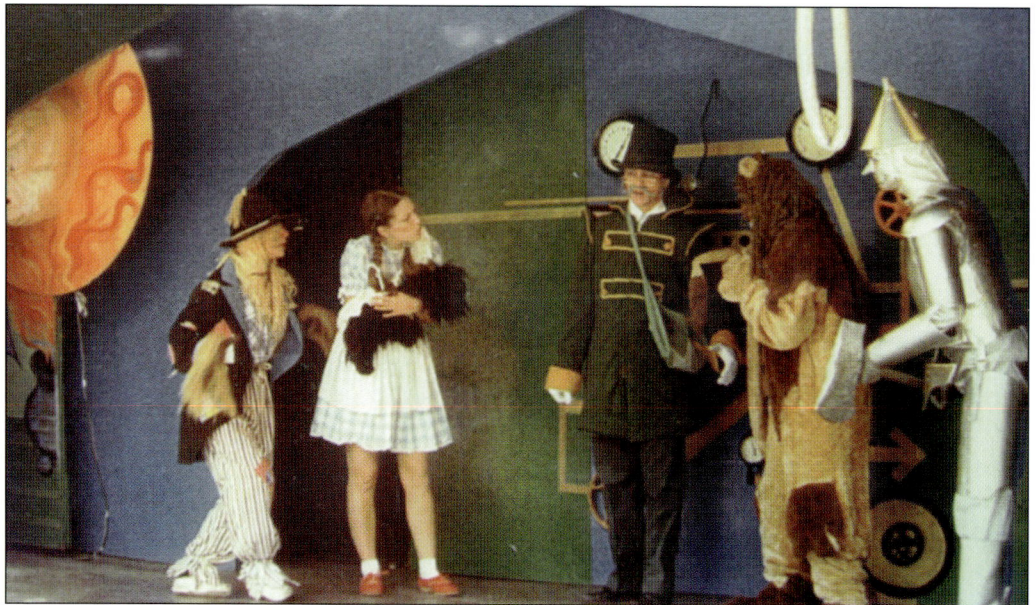

In the 1976 stage show, the Wizard actually appeared from behind his false face in order to present gifts to the other characters. He still refrained from admitting he was a humbug, though, which rather changed the moral of the original story. (Emerald Mountain Realty collection.)

Although Greenie the Mouse and the Dancing Mushrooms were no longer part of the act, the revised Magic Moment show still ended with Dorothy's rendition of "Over the Rainbow," salvaged from surviving soundtrack tapes. Again, she disappeared from the stage and reappeared in an overhead balloon. (Emerald Mountain Realty collection.)

Another addition to the post-fire park was that the characters would pose for photographs with young visitors for five minutes after each performance. Those visits were necessarily brief, as the next show began 15 minutes after the end of the previous one. (Angie Andrew Blackmon collection.)

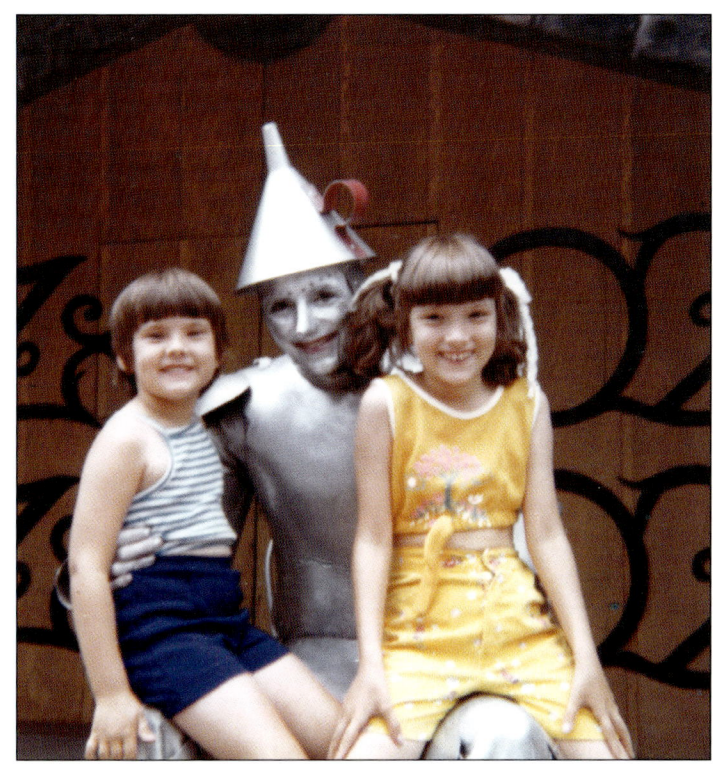

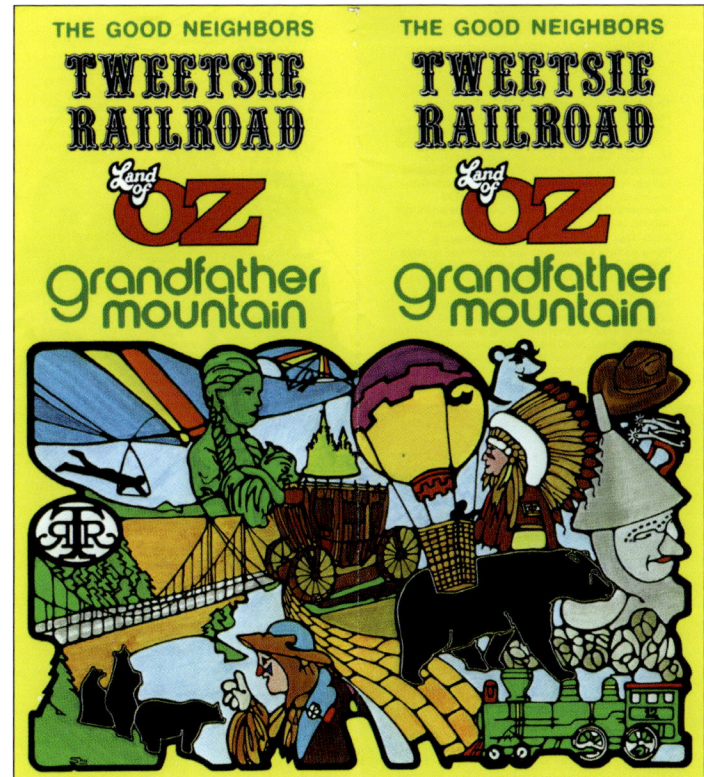

This late-1970s brochure is one of several that cross-promoted Oz with two of its neighbor attractions, Tweetsie Railroad (also owned by the Robbins family) and Grandfather Mountain, whose peak was easily visible from Oz's Judy Garland Memorial Overlook.

In Oz's very late years, further tweaks were made to the skits in order to have tour guide Dorothy interact more with the characters along the way. Notice that after undergoing many different looks over the years, the Wicked Witch now had a purple face. It was not enough to reverse the problems the entire tourism industry was suffering in the late 1970s, and the Land of Oz closed after the end of the 1980 operating season. (Both, Emerald Mountain Realty collection.)

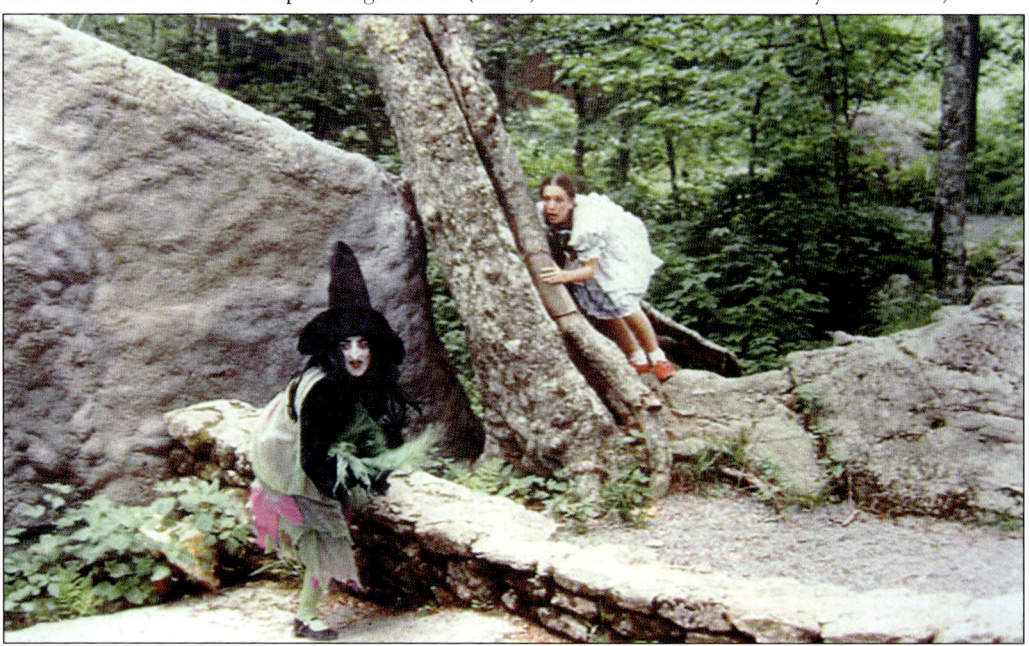

Five
THE MERRY OLD LAND OF OZ

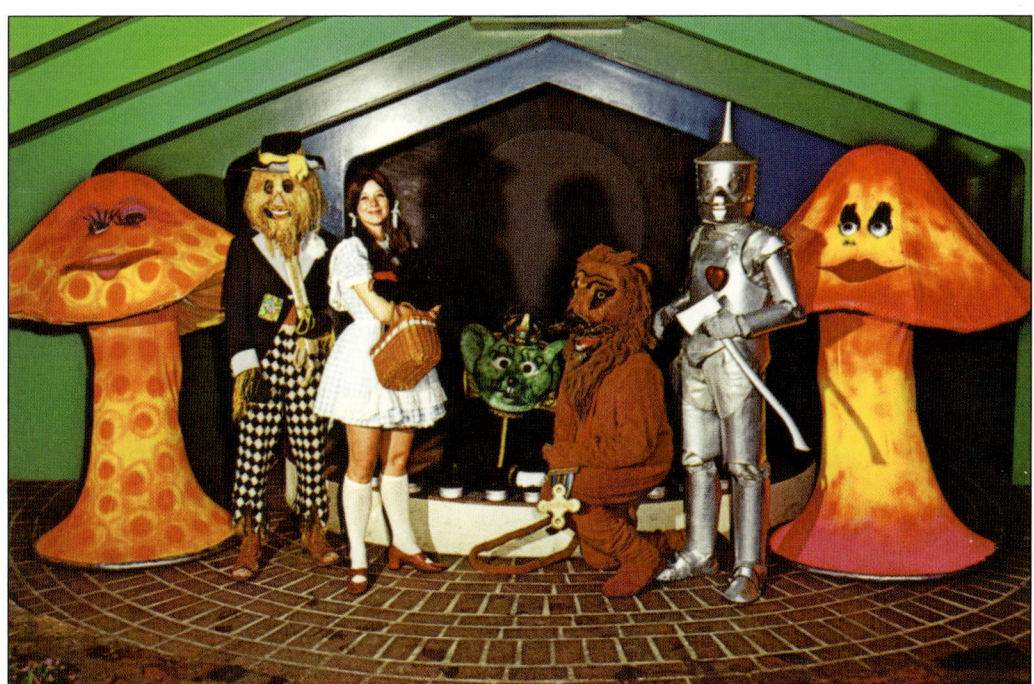

The cast of the Magic Moment show posed on stage for this handsome portrait. In this chapter, if Greenie deems readers worthy enough to proceed, they will see some of the many ways the Land of Oz was advertised and promoted throughout its history.

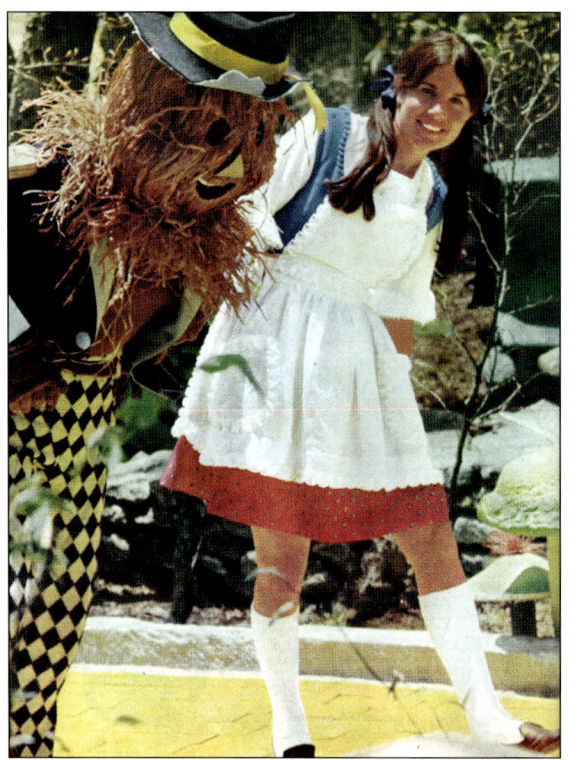

Readers have already seen tour guide Dorothy, balloon Dorothy, miniskirt Dorothy, and even dizzy Dorothy—now, here is waitress Dorothy. The earliest publicity photographs, taken before the park opened, featured a makeshift Dorothy outfit from a dress and apron borrowed from the Bavarian-themed Beech Mountain Ski Lodge.

Waitress Dorothy and her companions were the cover story of the July 1970 issue of *Holiday Inn* magazine. Since the article was necessarily written before the June opening, it contained some misrepresentations of some of the sights to be seen, such as saying that visitors could ride the balloons back to Uncle Henry's farm. (Chris Robbins collection.)

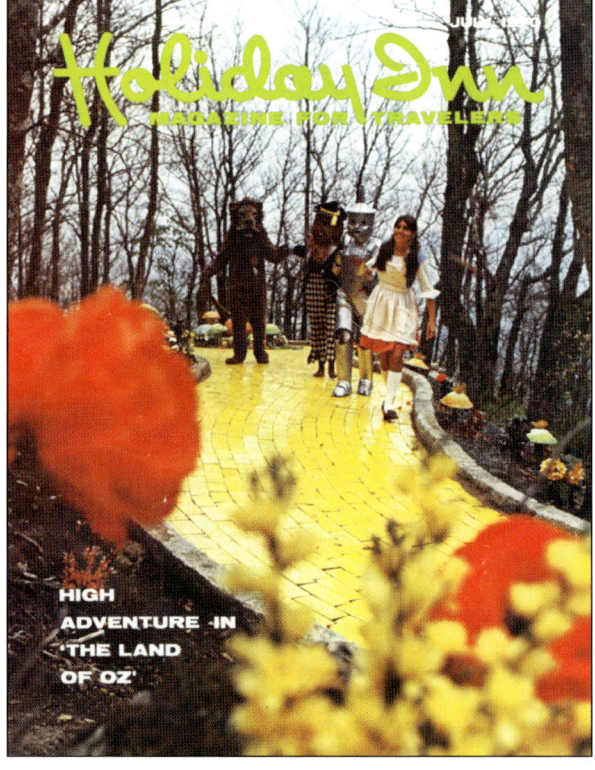

As waitress Dorothy stops to oil the Tin Woodman's rusty joints, pay special attention to her shoes. Instead of the red not-ruby-slippers, she is adorned with more sensible footwear. (Emerald Mountain Realty collection.)

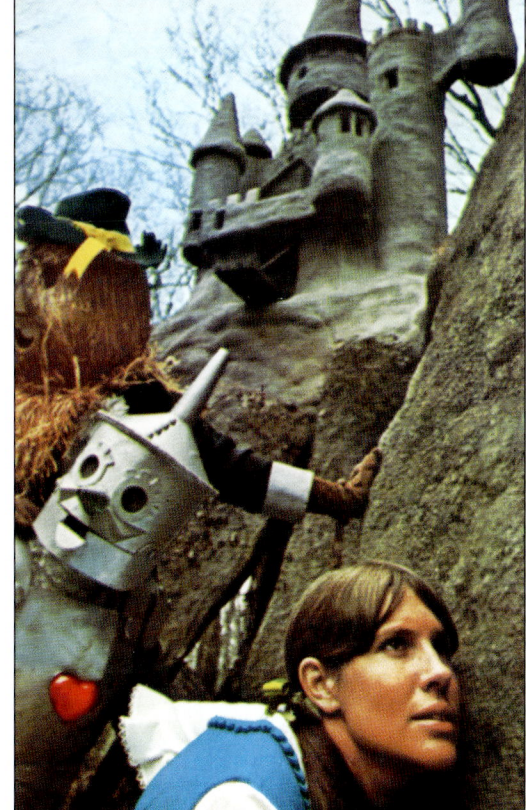

When this early pose was used in the park's souvenir book, the copywriter in charge of funny captions wrote, "How do you approach a witch's castle? Very carefully. Dorothy, the Tin Man and the Scarecrow keep a wary watch—every witch way—as they near the Wicked Witch's bailiwick."

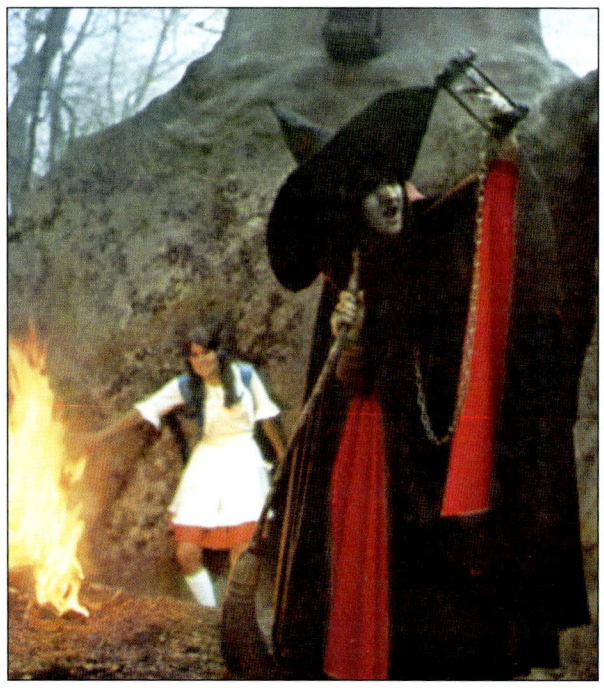

As has been seen, the Wicked Witch took many different forms over the park's 10 years, but the one in this pre-opening publicity shot, inspired by Margaret Hamilton's movie portrayal, was not one of them. Maybe that is why waitress Dorothy looks more amused than frightened.

Land of Oz You don't just see it; you live it.

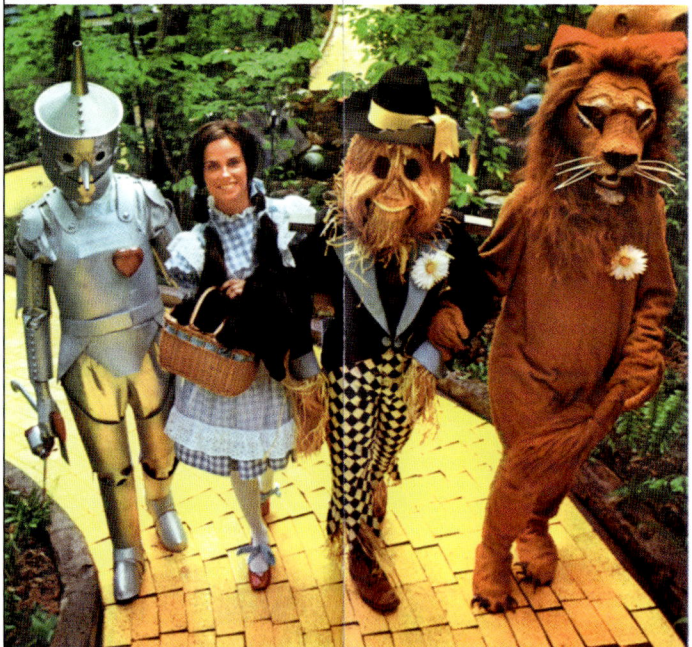

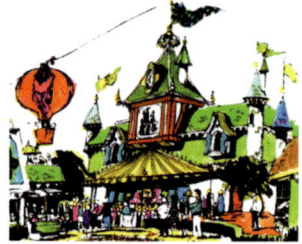

This isn't a play or a pageant or a movie.
It's the Land of Oz. Dorothy's dream world come true. And you live there and walk through there and maybe even pinch yourself to make sure you're not dreaming it all. You ride a sky-lift gondola or bus to the top of the mountain and there it is. Uncle Henry's farm and the animals. The tornado and the Yellow Brick Road. The Scarecrow. The Tin Man. The Cowardly Lion. The Wicked Witch.
Emerald City is even there. Complete with the terrible Wizard and a balloon ride, just like in Dorothy's dream. Look at the map and see how you get there.
Then look at the other side and see what you find there.

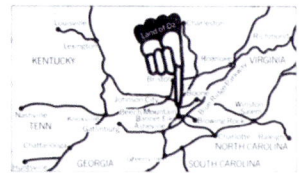

Open daily June 10 through Labor Day. Open weekends Sept. 11 through Oct. 31. Park opens 9 a.m., closes 7 p.m. Ticket sales start 9 a.m., end 5 p.m.

This early brochure included one of Joe Sonderman's preliminary drawings of the Emerald City. The text repeated one of the major changes that was made between the book and the movie, referring to Dorothy's adventure as a dream. (As far as Baum was concerned, it really happened, thus enabling the 39 stories that followed.)

The inside of this brochure, and its text, was the same as the one just seen, but the front used more current photographs. Notice the particularly striking angle chosen for the balloon ride, towering above the treetops.

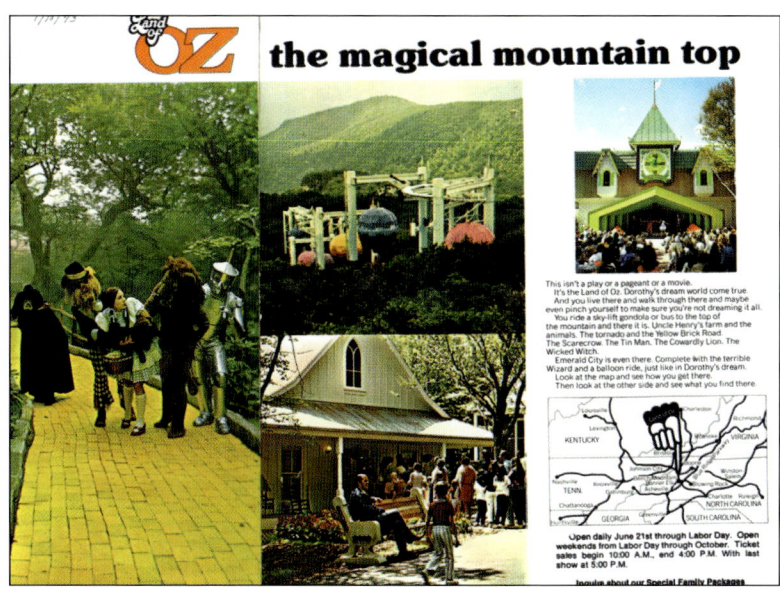

It has been seen before, and will be seen again, how often the Land of Oz was advertised in conjunction with its two nearby neighbors, Tweetsie Railroad and Grandfather Mountain. Some of the billboards in eastern Tennessee and western North Carolina also promoted the "Terrific Three" all at the same time.

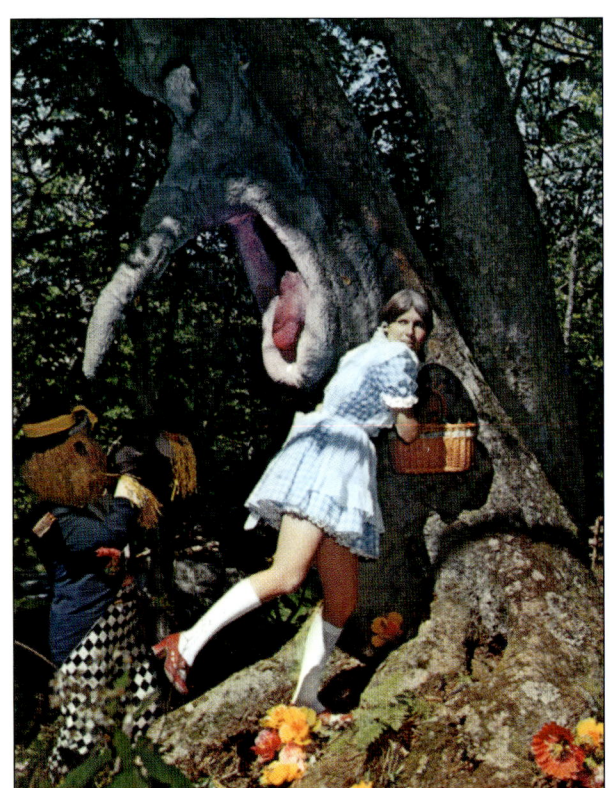

Some of the Land of Oz postcards deliberately attempted to recreate familiar poses from the movie, even though these parts of the story were never a part of what visitors would see. The Scarecrow's apple tree brawl and the crying Lion were just a couple of them. And readers will notice that waitress Dorothy has finally become miniskirt Dorothy once again.

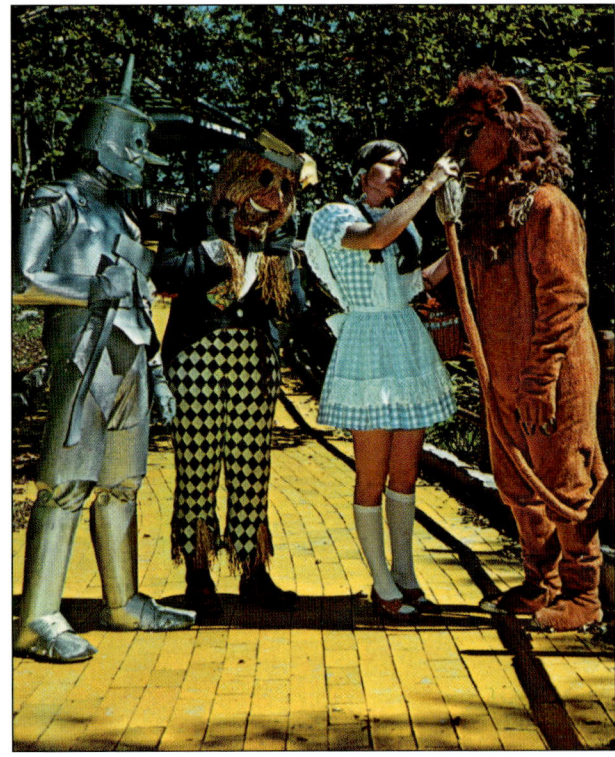

The characters' approach to the "Witches [sic] Forest" was straight out of MGM. However, the idea of the Tin Woodman fighting an aggressive tree while the others slept among the poppies came from someone else's imagination—straight out of Pentes's, perhaps? (Right, Chris Robbins collection.)

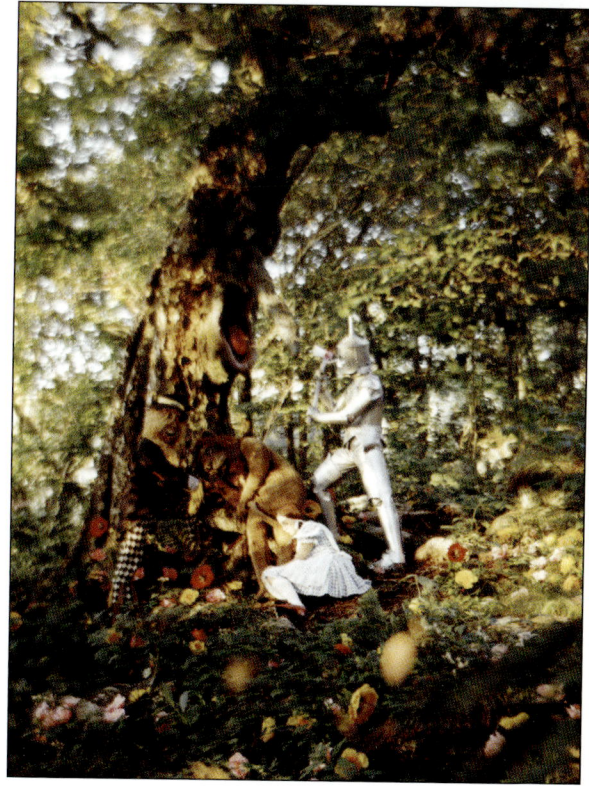

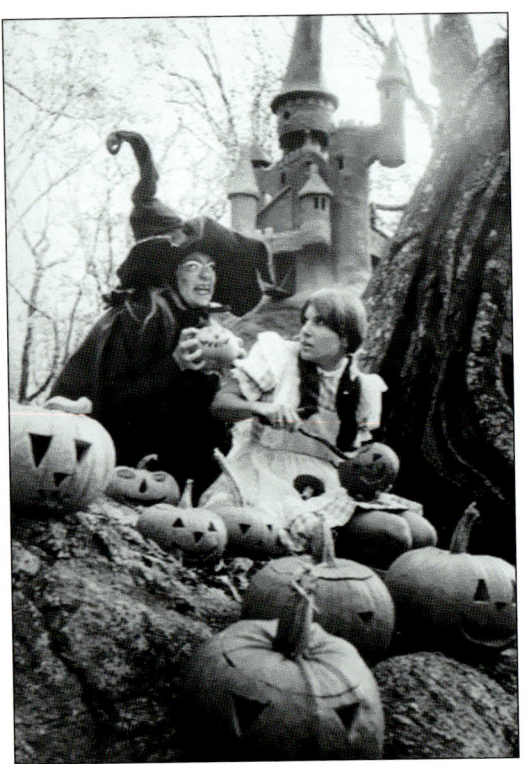

And then there were other publicity shots that resembled nothing ever seen before in books or movies. Appropriately, Halloween was a big deal around the Wicked Witch's castle, and here, she seems to be using the threat of bodily harm to inspire Dorothy's unwilling pumpkin-carving help. (Emerald Mountain Realty collection.)

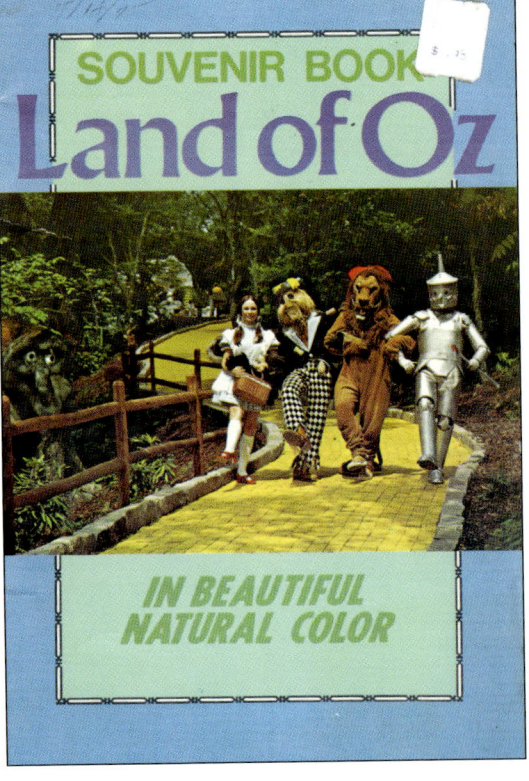

No decent theme park would have been without its own souvenir book, and Oz's 98¢ production was worth far more than its cover price just for the incredible collection of photographs it contained.

The inside back cover of the souvenir book included an order form for a ceramic music box and the vinyl record described below. Once the records were no longer available, that space was used to advertise sets of slides ($1.25 per set), pennants (98¢ each), T-shirts (a whopping $2.98 each), and balloons (three for $1, presumably not large enough to ride in). (Emerald Mountain Realty collection.)

The Land of Oz record album is one of the scarcest and most sought-after relics from the park. Side one contained the complete sound track of the 15-minute Magic Moment show, while side two featured other songs and pieces of dialogue heard in the park, including some eerie atmospheric music from the forest around the witch's castle.

A number of tourist attractions sold glasses made in this same style, with gold leaf highlighting the artwork. This one was particularly ambitious, since it attempted to recreate the highly stylized park map discussed earlier.

Many of the Land of Oz souvenirs featured artwork based on one of two publicity poses. This key chain, as one can easily see, used the pose that was featured on the record album cover on the previous page and the brochure back on page 62.

The other most common pose for souvenirs was this one, based on the photograph found on the cover of the souvenir book, although the quality and coloring of the artwork could vary greatly. Unfortunately, vintage T-shirts often develop the discoloration evident in this one. The yellow coffee mug maintained the "three good neighbors" tradition by also featuring Tweetsie and Grandfather Mountain.

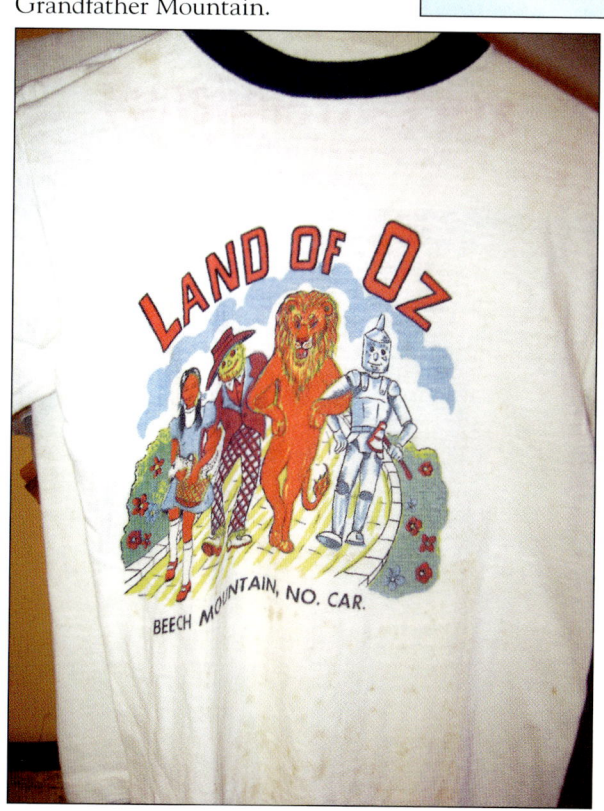

One of these adhesive badges was presented to each guest who successfully navigated his or her way to the Emerald City. Even more than 35 years after the park's close, a stack of them still exists on the property.

Hard as it may be to believe today, at one time, it was customary for theme parks and other attractions to employ workers who would go through the parking lot and physically affix a souvenir bumper sticker to each vehicle, whether the owner wanted one or not. Eventually, enough people must have complained, because parks such as Six Flags began posting signage to the effect of "leave sun visor down for no bumper sticker." Any remaining cars with their visors up were still considered fair game. Oz's bumper stickers were printed with the name in a fluorescent yellow-green that almost glowed in the dark. (Billy Ferguson collection.)

The Land of Oz

Beech Mountain
Banner Elk
North Carolina

$.79
7/18/75

There were at least two completely different postcard folders sold at the park. The one with the green cover, published by Dexter Press, was much larger than a standard postcard folder, with high-quality glossy photograph reproduction. The one with the white cover was much smaller, and the printing was of lesser quality, but the scenes in it were all credited to master photographer Hugh Morton of Grandfather Mountain.

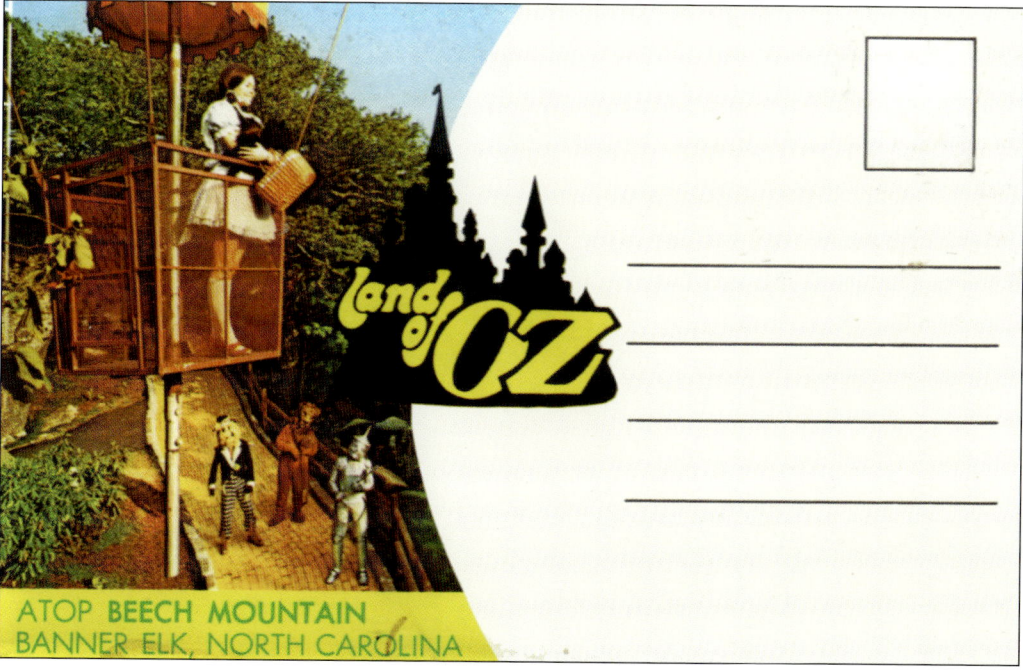

ATOP BEECH MOUNTAIN
BANNER ELK, NORTH CAROLINA

Land of OZ

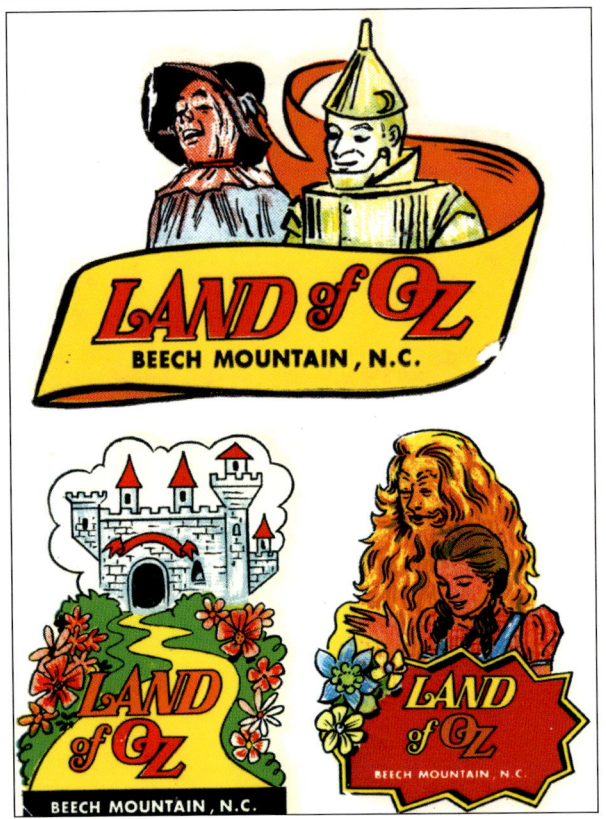

These oversize pin-back badges were available during the pre-fire era and were somewhat unusual in singling out the Wicked Witch for one of them. As is obvious, they were based on the original 1970 costume designs. (Emerald Mountain Realty collection.)

For the early 1970s, these water-based decals were even more unusual in that they unashamedly used the MGM designs of the characters, even though those were not being seen in the park at the time. The artwork of a generic castle, however, did not seem to originate with any identifiable source.

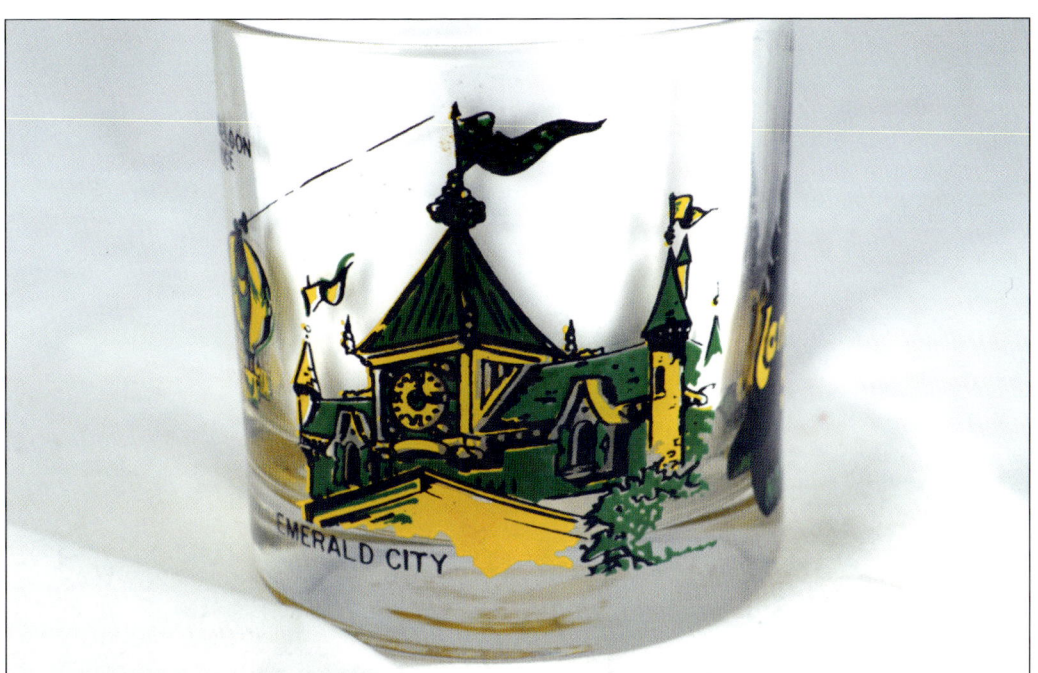

Joe Sonderman's concept artwork for the park certainly managed to get around. This souvenir glass again used a variation of his rendition of the Emerald City clock tower, just as the brochure did back on page 62.

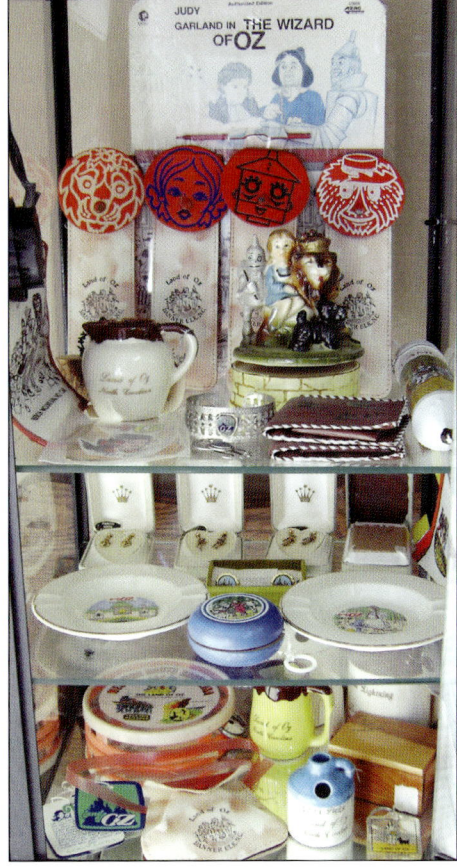

This display case shows some of the drastic evolution the Oz souvenirs underwent between 1970 and 1980. In the first few years, most of the souvenirs were custom-made using artwork depicting scenes from the park. As its fortunes declined, and especially after the fire, they changed into generic objects with "Land of Oz" printed on them in nondescript lettering. (Emerald Mountain Realty collection.)

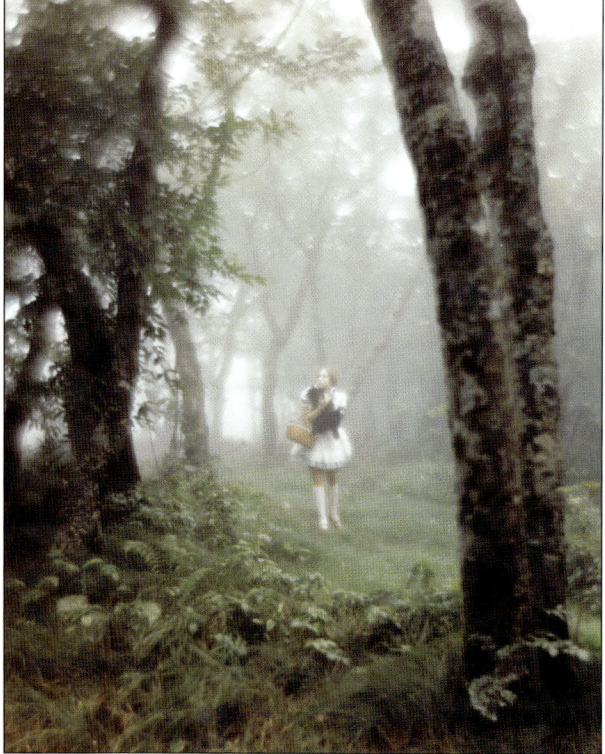

Examples of publicity photographs that were based on movie scenes have been seen, but there was another series that went off in an even more unusual direction. For example, consider this one, in which the Dancing Mushrooms combine with children visiting a wooded glade to produce a rather hallucinogenic experience. (Chris Robbins collection.)

Apparently, one day set aside for publicity work dawned somewhat foggier than anticipated. The photographer took advantage of it, producing poses such as this one of a lonely Dorothy (and the Toto hand puppet) lost in a strange forest. (Chris Robbins collection.)

There would not be much out of the ordinary about this scene except that Dorothy, the Scarecrow, and the Lion seem to have abandoned the Tin Woodman somewhere along the way. Unfortunately, the young boy and girl do not seem to miss him a bit and proceed merrily along. (Chris Robbins collection.)

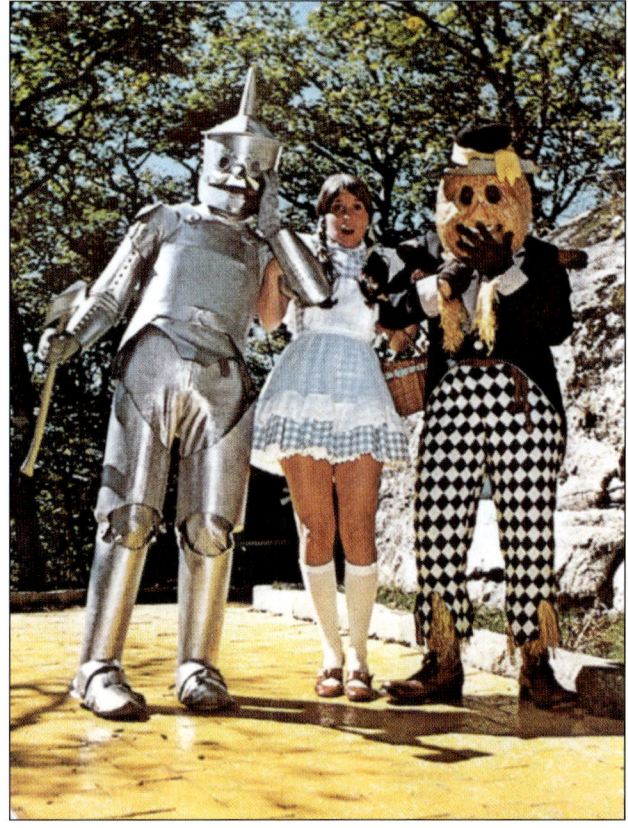

Considering that the original character heads could not change their expressions, the emotion conveyed in poses such as this one is all the more remarkable.

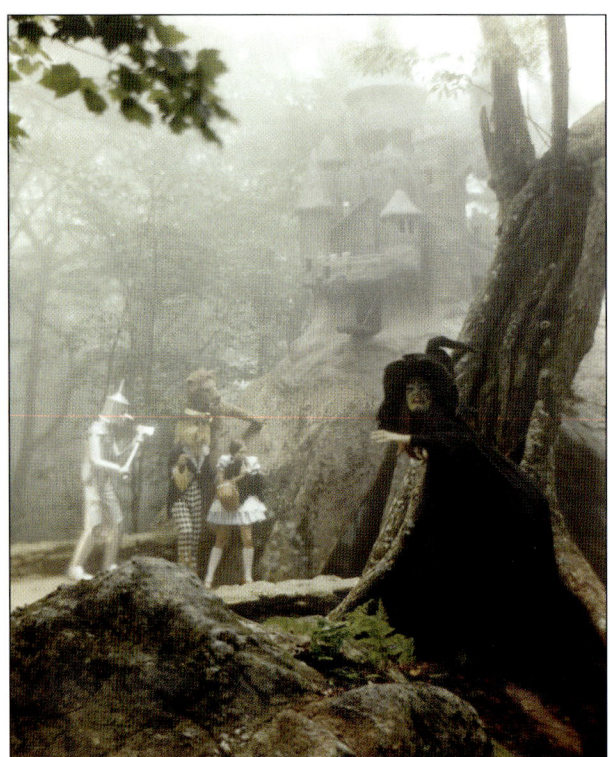

There always seemed to be interesting possibilities for photographs at the witch's castle. On the same foggy day that Dorothy was lost in the forest, the photographer chose this pose of the old hag watching the intruders approach her lair. (Chris Robbins collection.)

Nighttime photographs were rare, since the park was not equipped for being open after dark with any sort of regularity until 1976. As Dorothy and friends seem to be getting the drop on the Wicked Witch, the spectators at the left-hand side are wearing some of the original MGM movie Munchkin costumes. (Chris Robbins collection.)

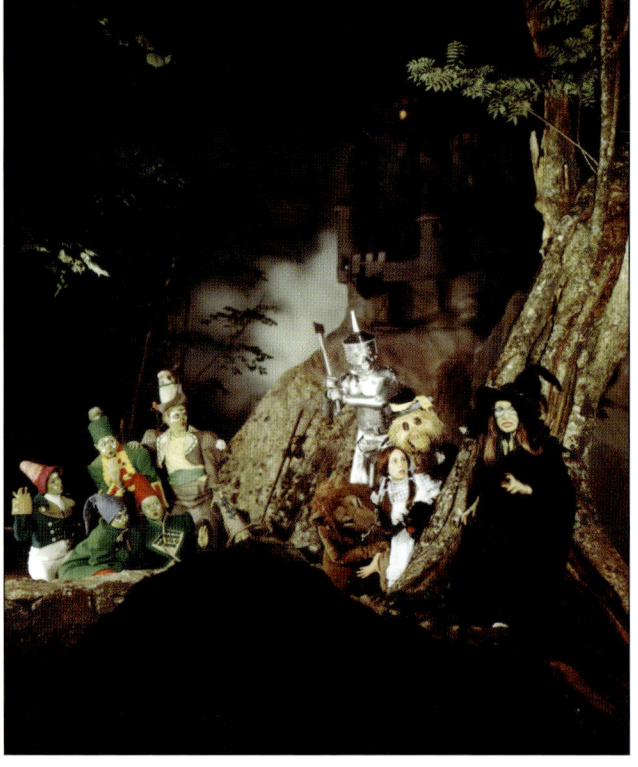

Those who like to root for the villain can rest easy, because here it looks like the witch has the upper hand once more. Actually, it is a bit difficult to tell whether Dorothy is more scared of the witch or her so-called friends. Oz could be a little weird whether one was dealing with good guys or bad guys. (Chris Robbins collection.)

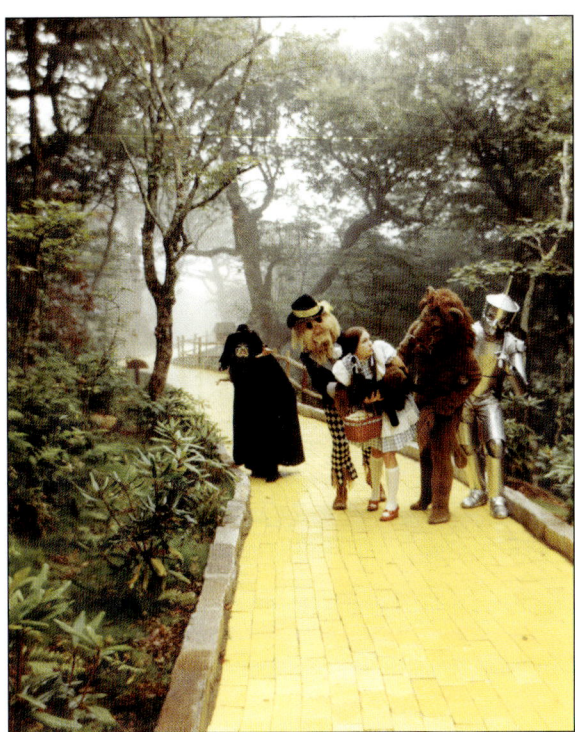

The logo used on most of the souvenir merchandise in the park's first few years featured a stylized silhouette representing the Emerald City. Someone created a most colorful view by superimposing it against the inside of one of the balloon ride vehicles.

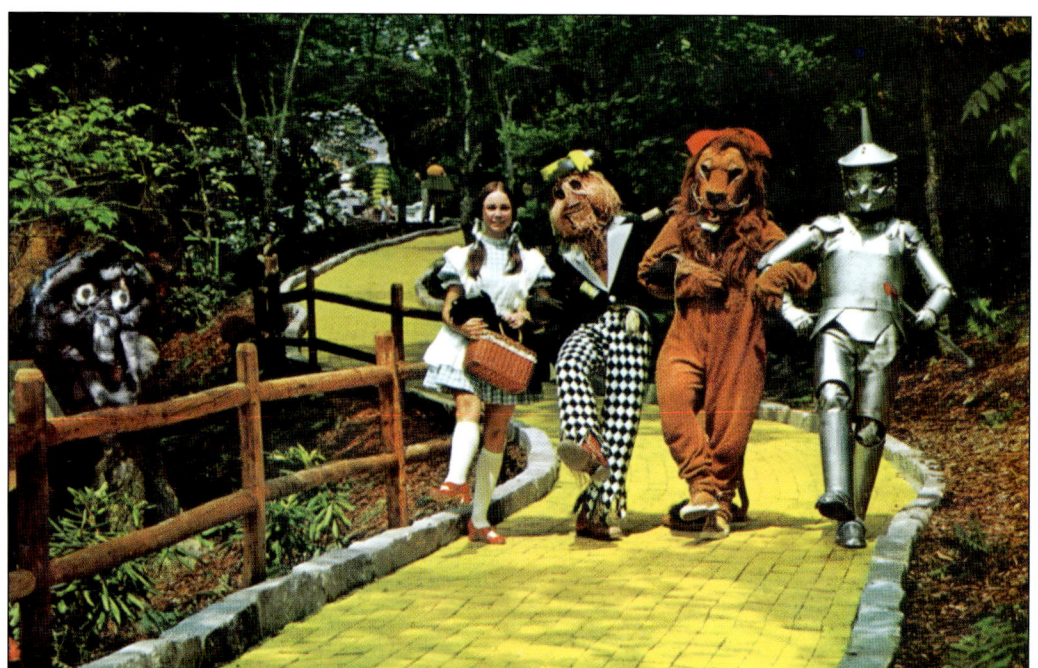

This is one of the most often reproduced publicity poses, and for good reason. Not only did it include all four main characters, but friendly old Mr. Apple Tree was in it as well. However, look closely at the background: they are actually skipping away from the Emerald City gate.

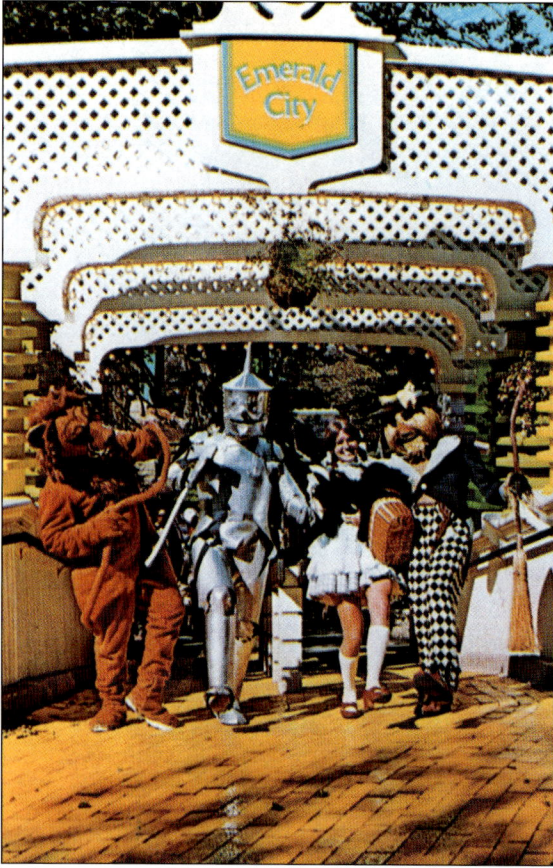

Well, maybe Mr. Apple Tree pointed out their mistake, because it looks like Dorothy and company made it to the Emerald City after all. They still seem to be leaving the city instead of entering it, though.

While Dorothy got to leave Oz in the balloon ride several times a day, for this beautiful pose, her traveling companions were able to join her in the basket.

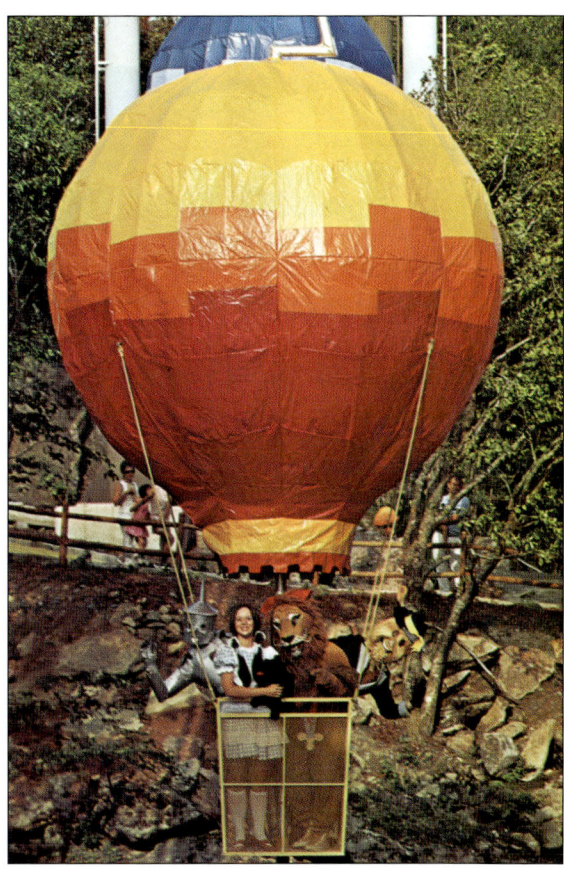

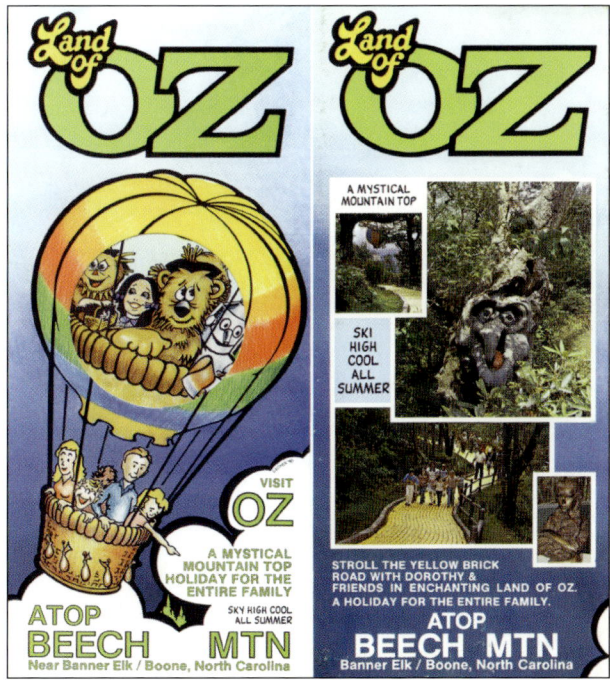

This late-1970s brochure featured an unusual cutout front, whereby the character faces from the inside showed through. The bronze Judy Garland bust in the lower right-hand corner is the replacement Austin Fox sculpted after his 1970 original was, unfortunately, stolen. (Chris Robbins collection.)

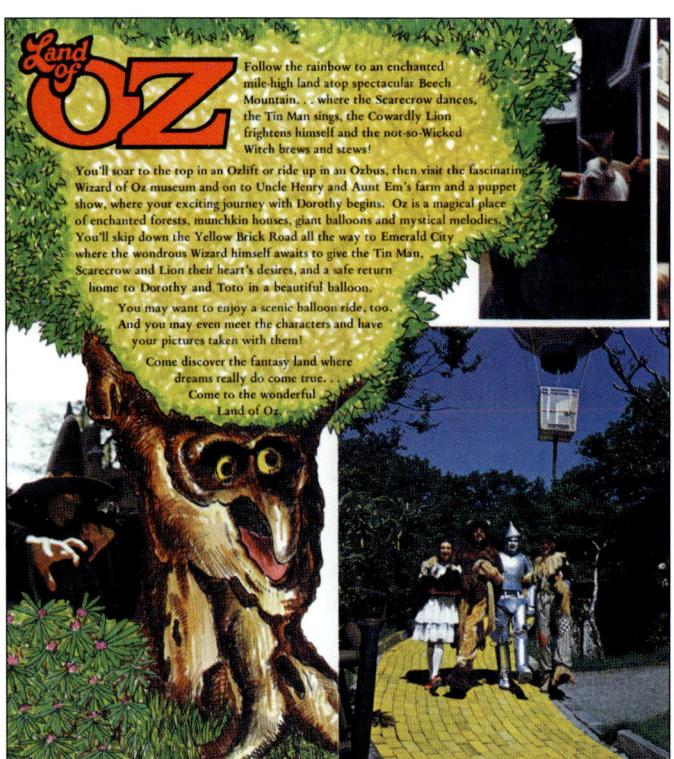

Mr. Apple Tree was prominent in the artwork for this brochure from near the end of the park's first life. The blue-sky pose with the characters on the Yellow Brick Road and the balloon ride overhead was also produced as a large framed poster. (Chris Robbins collection.)

And here it is, the last gasp for Oz as a commercial attraction. This was its final brochure, but even the "brand new show" it mentions was not enough to combat the changing face of tourism. For that matter, the Beech Mountain resort's summertime attempt to get people interested in skiing on grass was not a very big hit, either. (Chris Robbins collection.)

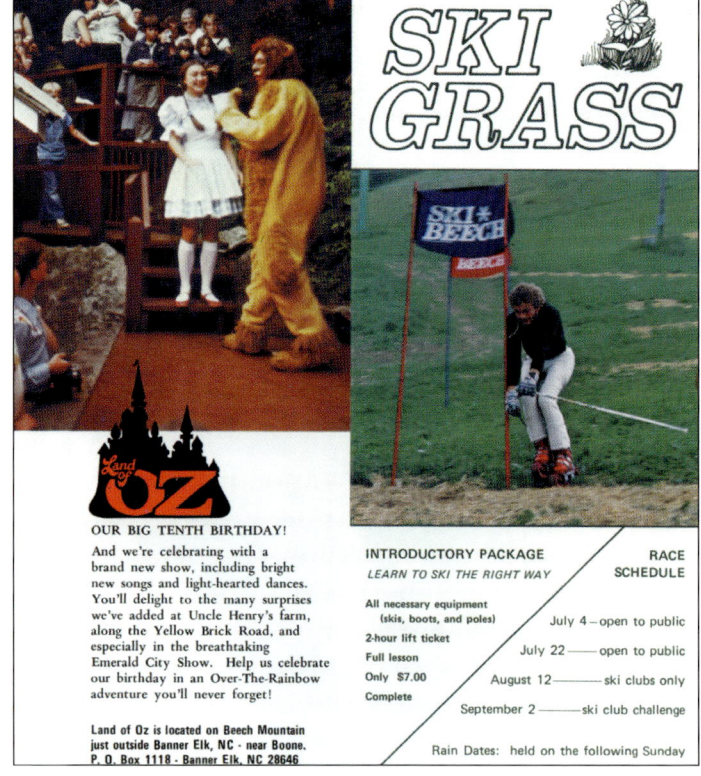

Six

BEYOND THE RAINBOW

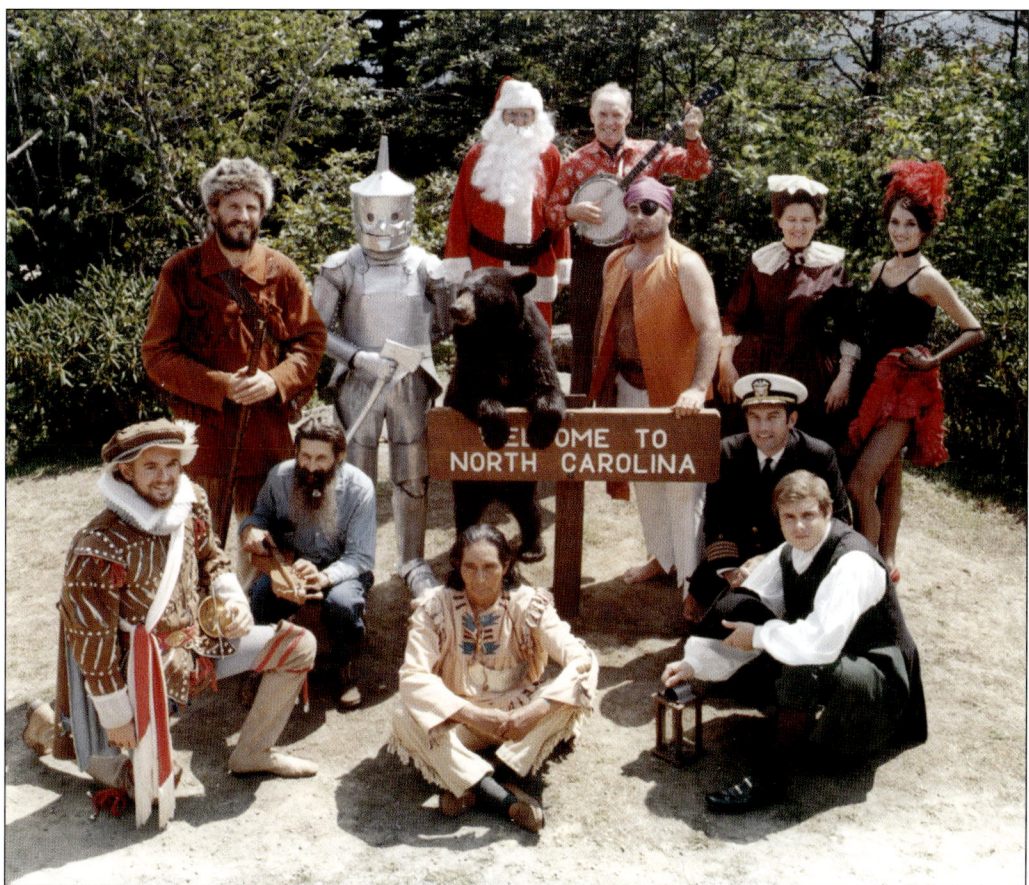

The Tin Woodman took a brief vacation from Oz to help promote North Carolina tourism with his peers representing other attractions: the USS *North Carolina* at Wilmington, Tweetsie Railroad, Santa's Land in Cherokee, the outdoor dramas *Horn in the West* and *The Lost Colony*, Grandfather Mountain's Mildred the Bear, and more. There was certainly no lack of variety in the state's tourism industry. (Photograph by Hugh Morton, North Carolina Collection, University of North Carolina at Chapel Hill, Wilson Library.)

The Tin Woodman also made a solo appearance to promote Oz in a late-1970s board game called *Fun Places in the USA*. Based on theme parks from sea to shining sea, in this fragment of the game board, the tin man shares space with mascots from Tennessee's Opryland USA, Florida's Gatorland and Lion Country Safari, and Indiana's Santa Claus Land (now Holiday World), among many others.

In 1957, Grover Robbins Jr., with brothers Harry and Spencer, first opened Tweetsie Railroad. Although it was approximately an hour's drive from Tweetsie to Oz, one of the balloon ride vehicles was placed near the Tweetsie parking lot to remind people to visit the other Robbins theme park. (Emerald Mountain Realty collection.)

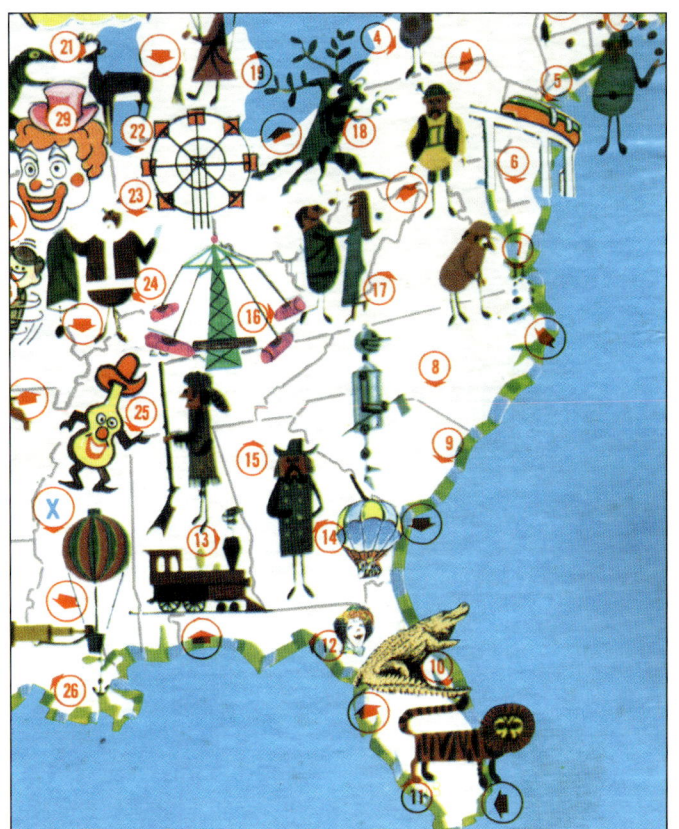

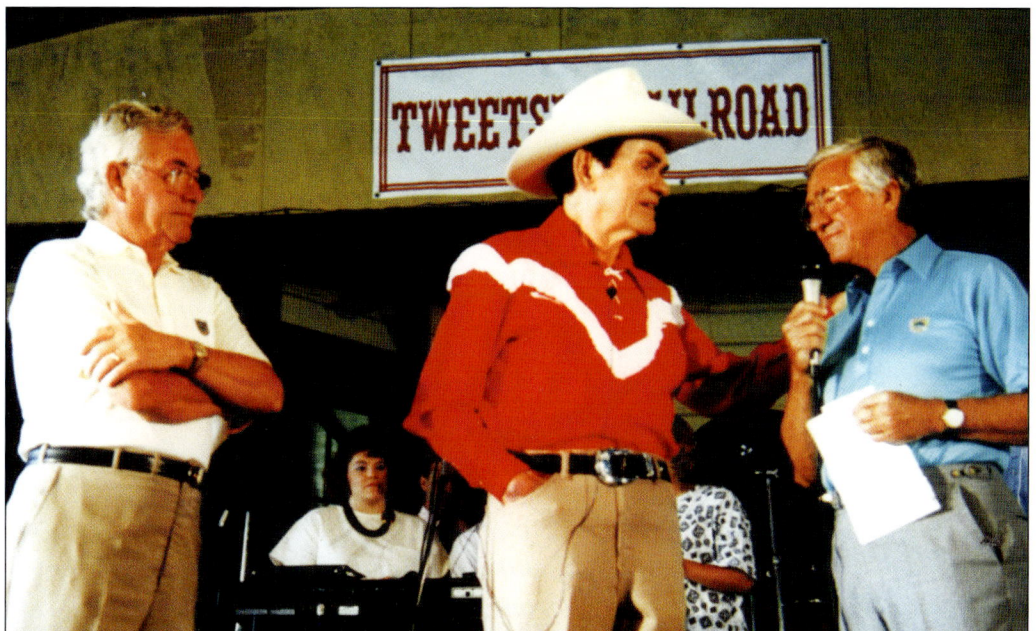

Spencer (left) and Harry Robbins (right) are seen here at Tweetsie with the attraction's longtime honorary sheriff, Charlotte kids' TV superstar Fred Kirby. Naturally, once the Land of Oz opened, it enjoyed much cross-promotion with Tweetsie. (Chris Robbins collection.)

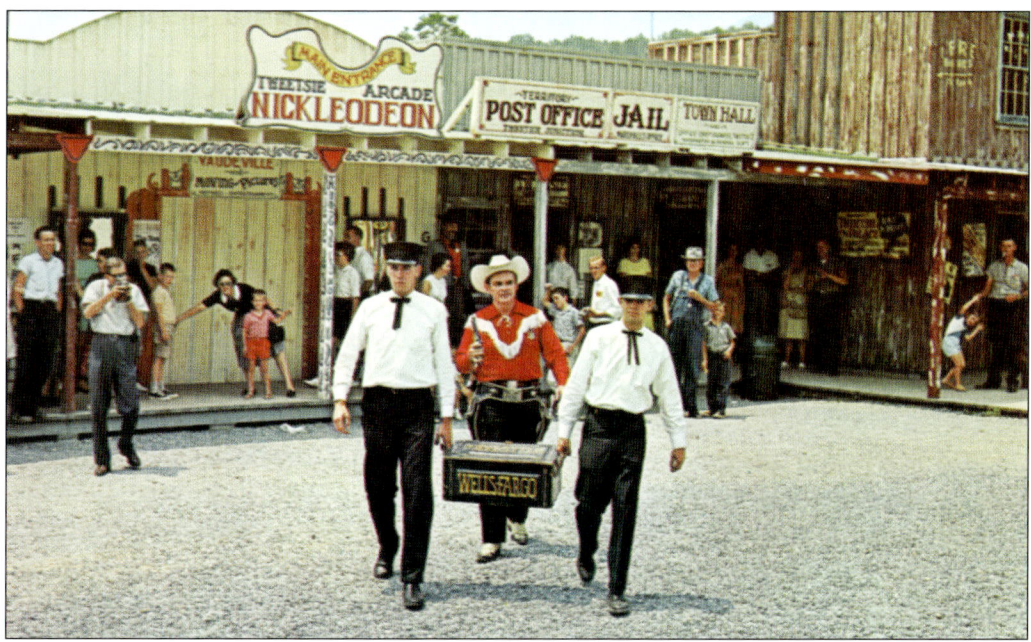

Even though Tweetsie Railroad did not start out as an attraction built around a Wild West theme, the overwhelming popularity of TV Westerns in the late 1950s soon caused its change in focus. Besides Sheriff Fred Kirby, saloon girls and desperate desperadoes soon joined the town's population, and they remain permanent residents to this day.

Even before beginning work on the Oz project, the Robbins family had enlisted the help of Jack Pentes for some attractions at Tweetsie. Pentes was responsible for the Castle of the Sleeping Giant, where the snoring behemoth could be visited by Jacks and Jills of all ages. He also designed the animated displays for the Mouse Mine train ride; it is tempting to think of the inhabitants as distant relatives of Oz's Mr. Greenie.

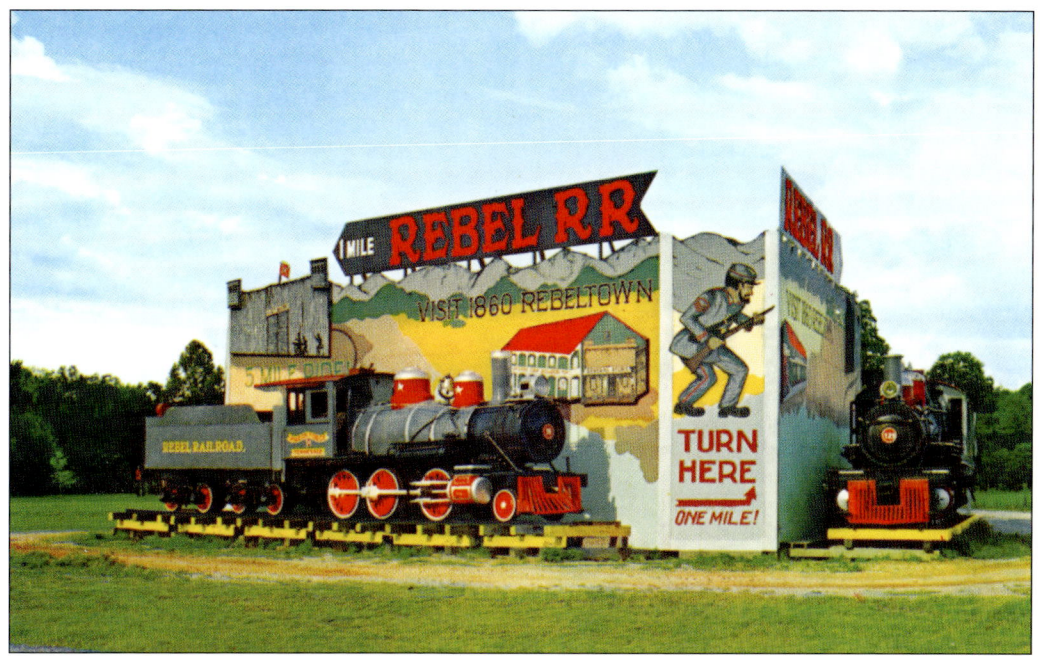

In 1961, the Robbins brothers took the Tweetsie concept and re-created it on the other side of the mountains in Pigeon Forge, Tennessee. As the Rebel Railroad, it translated the usual cowboys-and-Indians storyline into Confederates-versus-Yankees terms. After undergoing several name and ownership changes over the decades, it became known as Dollywood in 1986—and no one has to be reminded of the success it has enjoyed since.

As mentioned earlier, Grandfather Mountain's proximity to Beech Mountain meant that it shared advertising space with Oz at every possible opportunity. From this angle, it is not difficult to see how the mountain got its name, due to its ridgeline resembling the profile of a reclining old man.

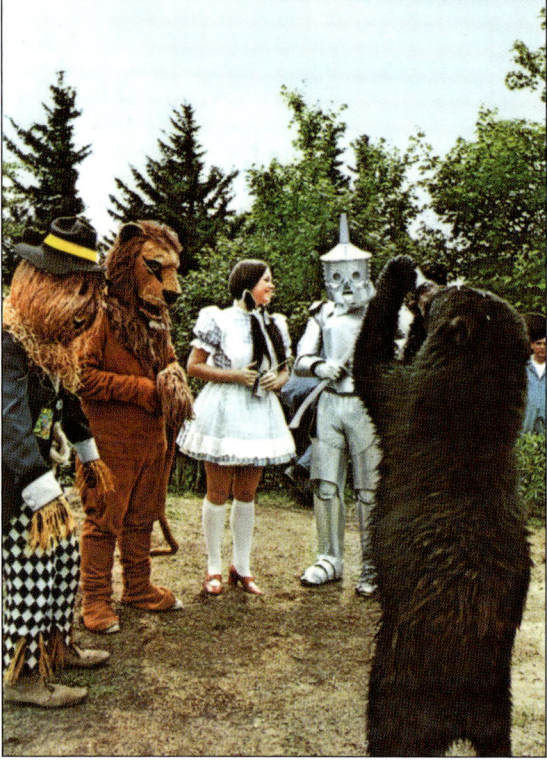

Getting back to the topic of Oz again, Dorothy and her friends took a detour off the Yellow Brick Road to visit Grandfather Mountain too. The attraction's mascot, Mildred the Bear, was like another child to park owner Hugh Morton, who made sure she was prominently featured in practically all of his publicity.

Seven
Return to Oz

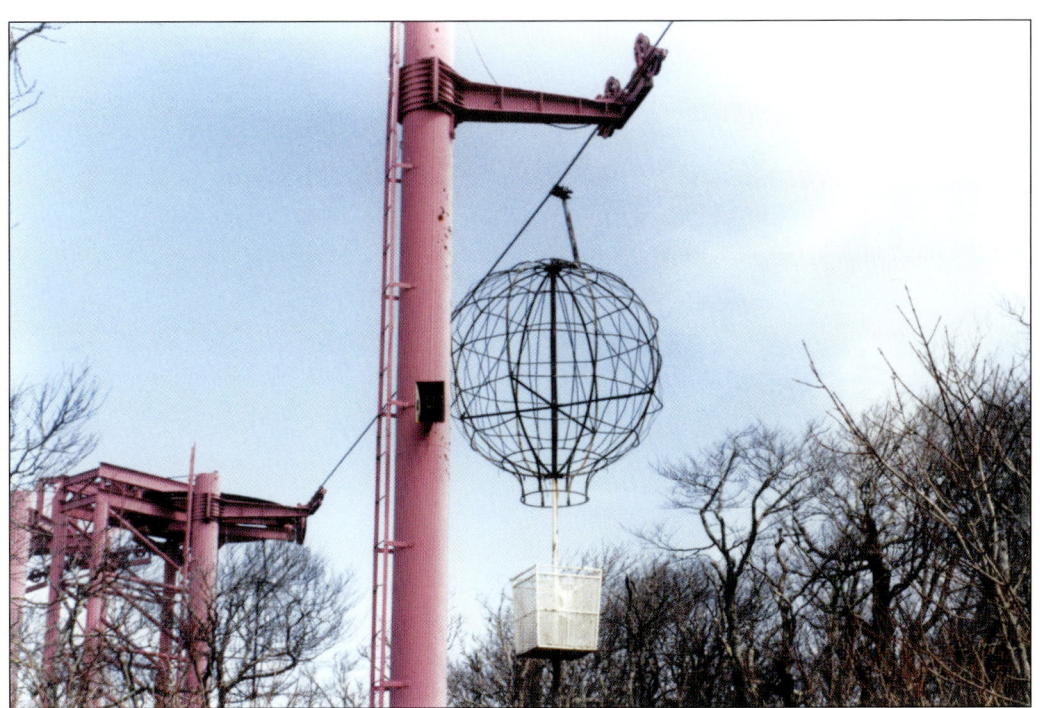

After closing in the fall of 1980, the Land of Oz was left to sit and deteriorate. This photograph was taken in 1985, when the remnants of the balloon ride were still hanging over the property. (W.L. Eury Appalachian Collection, Appalachian State University.)

With no effective restrictions to access, the Oz property was a prime subject for vandals and trespassers. The farmhouse sat with its windows and doors boarded up, and the relentless mountain weather was devastating to the surviving scenery and props. (W.L. Eury Appalachian Collection, Appalachian State University.)

At some point around 1986, the entire Emerald City complex was bulldozed to make room for planned residential development. The area at the far right of this view is where the theater and seating for the Magic Moment show once sat; the ground is still terraced to this day.

In 1990, Cindy Keller of Emerald Mountain Realty became the property manager for the park and the surrounding neighborhood. One of her most immediate goals was to prevent any further demolition or other damage to what was left of Oz.

One way of making sure the Land of Oz was no longer forgotten began in 1993. The annual Autumn at Oz festival started out small, but by 2016, it was attracting some 7,000 Oz fans (of the books, movie, and park) each year. (Jana Greer collection.)

A more recent addition to the park's limited operating schedule is a series of tours held on June weekends. More intimate than the frantic autumn event, tour guide Dorothy once again leads smaller groups down the Yellow Brick Road for some one-on-one interaction and role-playing. (Billy Ferguson collection.)

Artist Billy Ferguson has taken on the project of fashioning character costumes that re-create the look of the original 1970 Land of Oz characters, and the actors appear not only at the annual celebration, but also at other venues throughout the year. Miniskirt Dorothy lives again! (Billy Ferguson collection.)

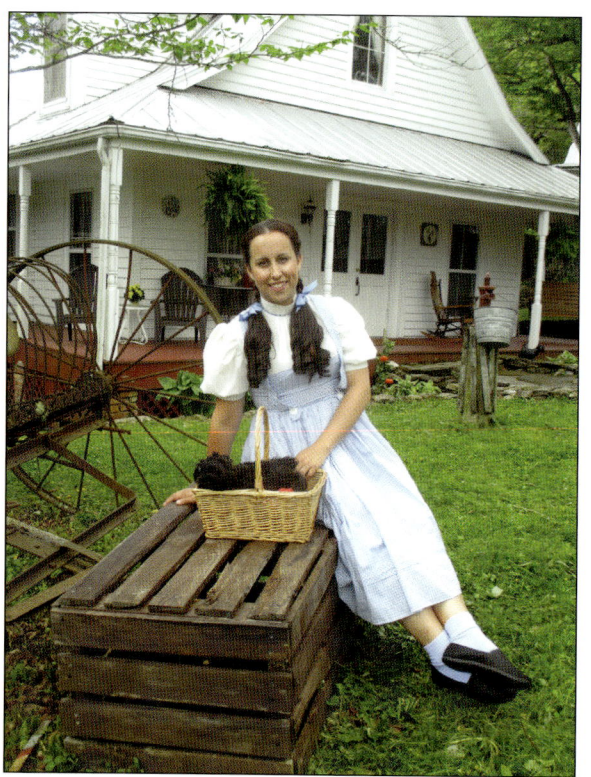

Today, Dorothy's farmhouse has been restored and is made available for rent as a vacation cottage throughout the year. It is a popular site for wedding receptions, parties, and weekend getaways. Uncle Henry's barn, the former petting zoo, now serves as a private residence.

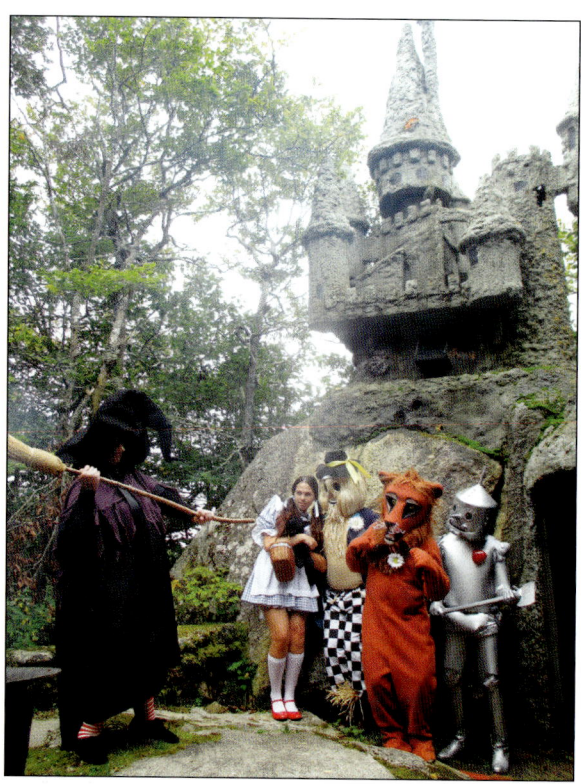

The original Wicked Witch's castle was one of those outdoor set pieces that did not survive the years of exposure to the weather. However, using period photographs and a lot of ingenuity, Cindy Keller and her crew managed to rebuild it in a form that closely matches its 1970s appearance. (Billy Ferguson collection.)

Today's iteration of the Oz Museum displays original park artifacts, all 40 of the Oz books by Baum and his successors, and the costumes and props bought at the MGM auction in 1970, minus Dorothy's gingham dress, which has never been recovered since the 1975 fire and break-in.

In the late 1990s, Cindy Keller recovered the balloon ride vehicle that served as an advertisement at Tweetsie Railroad, and today, it sits approximately where the loading area of the ride used to be. The concrete bases of the balloon ride's support poles can still be found tracing its original route throughout the property.

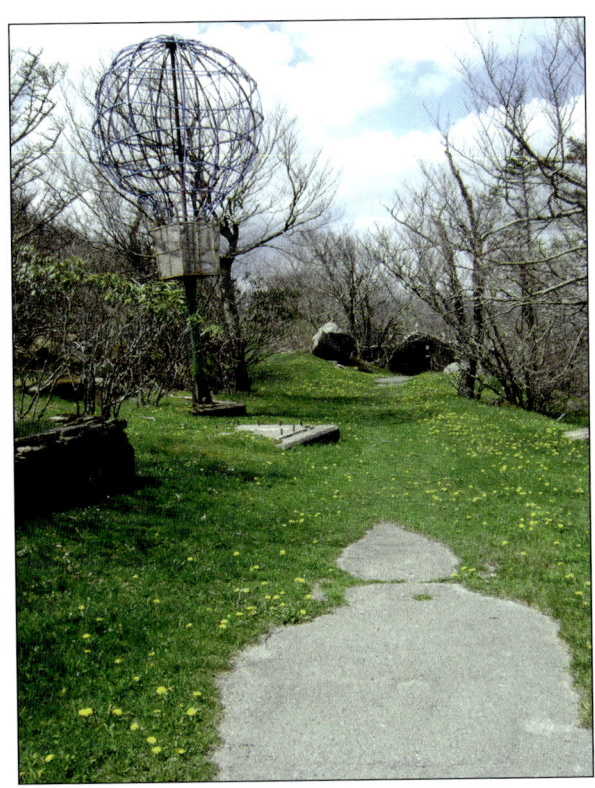

When the Emerald City was demolished in 1986, the scene must have resembled the closing sequence of Ray Bradbury's short story *The Exiles*, in which the title characters watch as the Emerald City of Oz splits in half and falls to the ground in ruins. The flat concrete areas in this recent photograph of its site are the excavated foundations of some of the restaurants and gift shops.

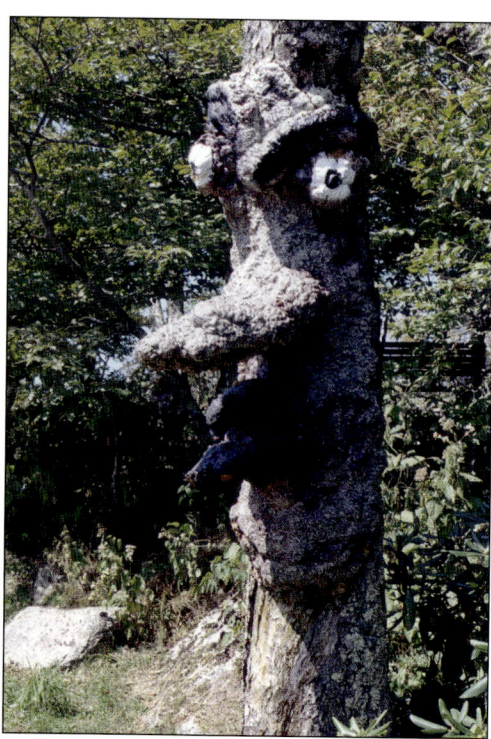

Thanks to some talented artists and sculptors working with Emerald Mountain Realty, the Styrofoam faces on some of the trees have been restored and leer at visitors as eerily as ever.

Jack Pentes, shown here in 2007, passed away in February 2015 at age 83. Even though he had been involved with many other projects during his lifetime, each of his obituaries credited Pentes as the originator of the Land of Oz park, proving that the work of a creative genius truly can live on after he is gone.

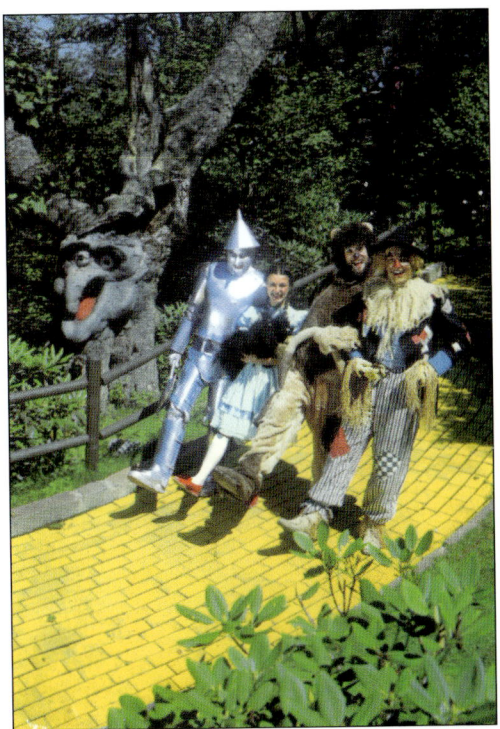

These two photographs were taken from basically the same spot some 35 years apart. Even though Oz is now private property and open only on special occasions and funny old Mr. Apple Tree has been reduced to a rotting stump, the Yellow Brick Road is still there—and who knows just where it may lead next?

Discover Thousands of Local History Books Featuring Millions of Vintage Images

Arcadia Publishing, the leading local history publisher in the United States, is committed to making history accessible and meaningful through publishing books that celebrate and preserve the heritage of America's people and places.

Find more books like this at
www.arcadiapublishing.com

Search for your hometown history, your old stomping grounds, and even your favorite sports team.

Consistent with our mission to preserve history on a local level, this book was printed in South Carolina on American-made paper and manufactured entirely in the United States. Products carrying the accredited Forest Stewardship Council (FSC) label are printed on 100 percent FSC-certified paper.